Oxford in Watercolours

Hubert Pragnell

Spire Books Ltd

PO Box 2336, Reading RG4 5WJ
www.spirebooks.com

Spire Books Ltd
PO Box 2336
Reading RG4 5WJ
www.spirebooks.com

CIP data:
A catalogue record for this book is available
from the British Library
ISBN 978-1-904965-30-5

Designed and produced by John Elliott
Text set in Bembo
Printed by Information Press Ltd. Eynsham, Oxford.

Contents

Beyond the Colleges

Preface

There are few places in the world better known than Oxford. As one of the most interesting cities in Europe and with one of its oldest and greatest univesities, it attracts visitors and students from across the globe. I have been fascinated by the city, its history and buildings since childhood, when I remember my parents showing me a picture of the High Street from outside The Queen's College – perhaps one of the most celebrated viewpoints with the tree on the right breaking the visual journey towards the spire of St Mary's. Later, whilst on holiday near Henley-on-Thames, I cycled with two friends to Oxford and found it my idea of an architectural heaven. We only saw a few colleges that day, including Magdalen with its beautiful grounds and Christ Church and its hall, but it was a truly magical experience.

Whilst studying fine art at the Ruskin School of Drawing and Fine Art I got to know Oxford more intimately, including its suburbs, riverside and nearby countryside, and not forgetting its wonderful libraries and the Ashmolean Museum. Over the years I have seen changes; new shops, modern college extensions, and buildings in the forefront of architectural innovation, as well as the pedestrianisation of Cornmarket Street. I love Oxford and I hope this selection of pictures conveys something of my enthusiasm for its buildings and gardens, as well as a little of the life of 'town and gown' as people go about their work and play. I have tried to select original angles – very hard in this most painted of cities – and hope I will be forgiven if there are buildings and viewpoints left out which you feel ought to have a place.

For Dorothea, Charlotte & Christian who each know and love Oxford.

Oxford from South Hinksey

Throughout the world Oxford is known as the 'city of dreaming spires', and there is no better angle to appreciate this than from the hillside above the western by-pass at South Hinksey. The view is perhaps best on a winter's day with the trees retaining that tinge of brownish orange in the late afternoon sunlight. It was a mile or so to the north on Boar's Hill that Matthew Arnold was inspired in 1853 to write *The Scholar Gypsy*. Arnold subsequently wrote in 1884, 'I cannot describe the effect which this landscape always has upon me – the hillside with its valley, and Oxford in the great Thames valley below'. Muirhead Bone painted this view in 1946, when the gasholder in St Ebbes, softened with smoke from the Great Western Railway, broke the skyline beyond the flooded meadows. Although Oxford has grown, its development has perhaps been forestalled to the west of the railway by the waterlogged ground. Long may it remain so!

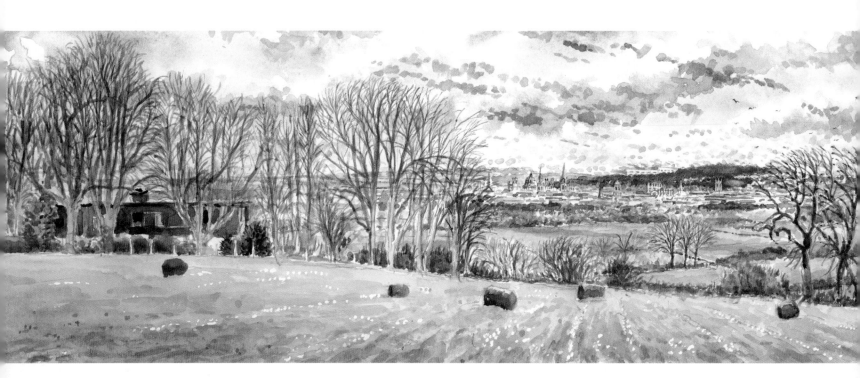

Introduction

Why another book on Oxford? This is a personal impression of one of the most beautiful cities in Europe, where there is the almost perfect marriage of landscape with buildings. Oxford is a city which has come through the centuries without major destruction by fire or war and yet does not turn its back on the 21st century. It has the most modern of academic buildings as well as the oldest, as a walk along Merton Street or South Parks Road will demonstrate. Some colleges contain buildings ranging all the way through from the medieval Gothic, through the classical, to the late 20th century. Most are in honey-coloured stone from Taynton, near Burford in the Cotswolds, or creamy white stone from nearby Headington; but one college, 19th-century Keble, is in red brick and took almost a century to subdue its critics. Oxford is also a city with suburbs of great character. Take a walk down Beaumont Street or up St John's Street and you might think you are in Bath with stone terraces sporting balconies and verandas, or walk up the Banbury or Woodstock road and you will pass numerous Victorian red-brick Gothic villas built to accommodate dons and their families. Go east up Headington Hill to the expansion of the 1930s with roads of neat houses set well back behind mature gardens, or along the Cowley and Iffley roads towards the estates laid out to accommodate the growing work-force and their families of the Morris Motor Works. Out to the west beyond is Cumnor Hill with its detached villas which may be described as the Hampstead or Highgate of Oxford.

Oxford has been so photographed and painted that it is almost impossible to find original viewpoints so I hope I will be forgiven for including some familiar views. Using the double-page spread of my sketch book I have tried to create wide-angle views, often from pavement level. Many were painted wholly on-site from a stool on a busy pavement, or standing with my paints and water jar resting on a doorstep or window-ledge. Sometimes I had to bend down to my material on the pavement or even a traffic island which was good for exercise, if not comfort. All have been made between 2002 and 2010. The emphasis is architectural, which is, after all, the first appeal of the city, followed by the gardens and trees. Although an artist can choose what he or she wishes to include or leave out, I have tried to convey a truthful impression, and so have included cars and buses, lamp posts, bus stops, shop signs, scaffolding and other items of street furniture. Oxford, after all, is not trapped in a time-warp, and every so often sprouts a new 'dreaming spire', such as the ziggurat of the Said Business School. I hope this book will serve as a record of the city as it was in the first decade of the new millennium. From the artist's point of view there is no better way to study the features and colours of the buildings than to draw them on the spot. How easy is it to spot the real from

the false windows in Peckwater Quadrangle at Christ Church? How many visitors, or even undergraduates, notice the row of lion heads on the St Giles façade of St John's College?

I have tried to capture Oxford in all seasons. Whilst a blue sky is almost imperative to promote a college to prospective applicants, or to project the image of the city in guide books and post cards, I have tried to depict Oxford in winter as well as summer, in autumn as well as spring. It is in autumn when we often have strong sunlight, but sufficiently low to create dramatic silhouettes of battlemented parapets and pinnacles against opposite quadrangle walls. It is then that the front quadrangle of Lincoln burns bright red and orange with its creeper-clad walls set off against the most famous lawn in Oxford. It is dramatic indeed to see the huge bulk of the drum and dome of the Radcliffe Camera projected against the south wall of the Bodleian Library on the north side of Radcliffe Square. To see the effect of the low sun catching the curve of the north side of the High Street on an early Sunday morning, when there is little traffic, is unforgettable, as also is the autumn sun setting directly behind St Martin's church tower at Carfax, so throwing the buildings on either side of the High Street into stark silhouette. It is a magical atmosphere in a college garden as the sounds of madrigals drift out as the summer evening light falls on a stone classical façade framed in the trees.

No longer can dons saunter down the middle of the High Street as they did in the days of J.M.W. Turner, his namesake and contemporary, Willam Turner, and his fellow Oxford artist, James Malchair. Even in Broad Street where through traffic has been banned, pedestrians have to watch for cyclists and tourist buses. The one place in Oxford which has regained its 18th-century calm is Radcliffe Square which is pedestrianized, and where the railings round the Camera, torn down in the War, have been replaced to keep the grass in immaculate condition. Even the cobblestones have been re-laid on either side of the Camera. Now the peace is only shattered by the chimes or bells of St Mary's, the sound of a game of croquet in Exeter Fellows' Garden, or students chatting on their mobile phones.

This book then is a portrait of the architecture and natural beauty of the city and its university. It attempts to show the ordinary as well as the world famous, ancient as well as modern; streets seen by everyday shoppers, students and visitors alike. It will also show a few corners, perhaps only known to those who have been fortunate enough to study here, or indeed who live here. Oxford's waterways have not been forgotten with the Thames or Isis, and Cherwell providing leafy and secluded walks with distant views of the skyline, most memorably across Port Meadow. It does not pretend to be a complete picture; it has to be selective so some colleges do not appear, such as Corpus Christi and Pembroke among the ancient foundations, or Green Templeton among modern ones. This is not to say they are architecturally undistinguished, Green Templeton has actually incorporated James Wyatt's neo-classical Radcliffe Observatory as its dining hall and senior common room. The book includes events which make up the Oxford calendar for town and gown; Degree Day at the Sheldonian, the Oxford Martket at Christmas, and the Encaenia Procession. Most pictures were completed on the spot. If lucky, I found a seat in a college quadrangle or garden, or stood discretely in a corner with my paint box on a window sill and my water, in a jam jar on a doorstep or pavement. To paint the view of Oxford from South Hinksey it involved walking across a very muddy field in February, and braving a biting wind for several hours. Those who know

Oxford well will notice that the 'uniform' of the buses has changed slightly and some shop fronts as well. Trees have grown and creeper has spread.

It is natural that comparisons are often made with Cambridge. In spite of their similarity as collegiate university cities, it is impossible to claim that one is the more beautiful, or the more academic. To the visitor the period of year, the weather, or even the light can sway one's view. Many will claim that the Backs at Cambridge give a unique beauty, and certainly Oxford does not have a procession of grand buildings lining the banks of the Thames and Cherwell. The latter is more intimate with its numerous tree-lined bends and islands, a joy to punt parties as they make their way past Christ Church Meadow and under Magdalen Bridge to the upper reaches beyond Addison's Walk. The sight of the buildings of Magdalen College in the golden afternoon sunlight is magnificent. A major difference of course is that Oxford is a city of stone whereas Cambridge is largely of mellow brick; Queens', Trinity Hall, and Jesus have a very special warmth created by their red brick. Cambridge colleges are more irregular in plan, such as Pembroke and Jesus, whereas Oxford's seem to have created a 'collegiate style' with battlemented gatehouses and enclosed quadrangles as we see in Turl Street, and to be subsequently imitated in late 19th-century colleges such as Mansfield and Manchester, as well as at universities elsewhere in Britain and abroad. Apart from King's Parade, Cambridge does not have any grand streets. There is nothing to approach Oxford's High Street or St Giles, or indeed Broad Street. Some may also claim that Oxford's streets have more trees, as for example in Parks Road, and the remarkably preserved Victorian suburb of North Oxford. Many rank the interior of King's College chapel to be more magnificent than anything in Oxford. In size yes, but the visual intricacy of the fan and pendant vault of the nearly contemporary Divinity School is a worthy competitor.

And then there is the monumental grandeur of Radcliffe Square, now cut off from through traffic and dominated by the circular drum of James Gibbs's Camera. It has a special magic and not least at night under a full moon. Around it is an assortment of buildings from the university church of St Mary on the south, the Gothic cloister and towers of All Souls on the east, the Bodleian on the north, and Brasenose with its curious 17th-century transitional architecture on the west. In the end the choice has to be personal, but nobody will deny that Oxford is one of the most beautiful cities in Europe with a skyline now protected, like Florence, against unsympathetic encroachment, and with treasures stored within its colleges, libraries and museums which can rival those of Rome and Florence.

Acknowledgements
Any book which is about architecture and styles involves key facts such as dates and architects or craftsmen. These can sometimes be a source of contention. I am therefore grateful for Geoffrey Tyack's comments, suggestions and minor corrections.
Naturally I owe a debt of gratitude to all at Spire Books for expressing such enthusiasm for my watercolours and supporting the publication of what started off as a personal visual diary or sketchbook, in particular Geoff Brandwood, John Elliott and Linda Hone.

A View from the Tower of St Mary the Virgin

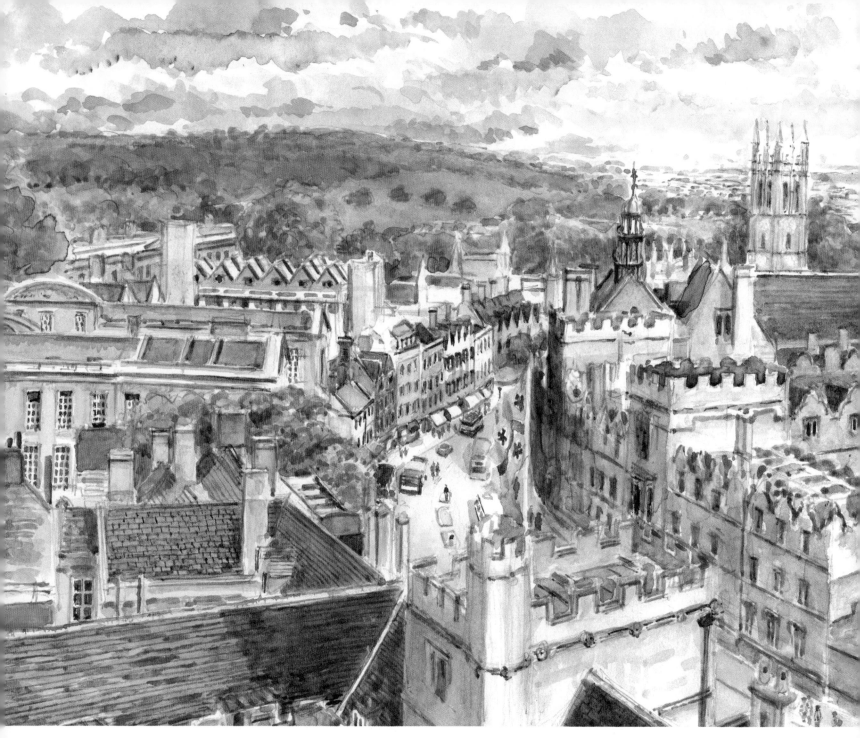

It is appropriate to survey the city from this point as, not only is the tower in the centre, but it is also at the heart of the medieval university. Much of the church was rebuilt in the late 15th century although the tower may be late 13th century and the spire, with its lavish decoration, was completed in about 1325.

In the immediate foreground is All Souls College, founded in 1438 by Henry Chichele, archbishop of Canterbury, with the original front quadrangle and gatehouse surviving. Beyond is The Queen's College, rebuilt in the early 18th century. Immediately to the right of the flag, on the south side of the High Street

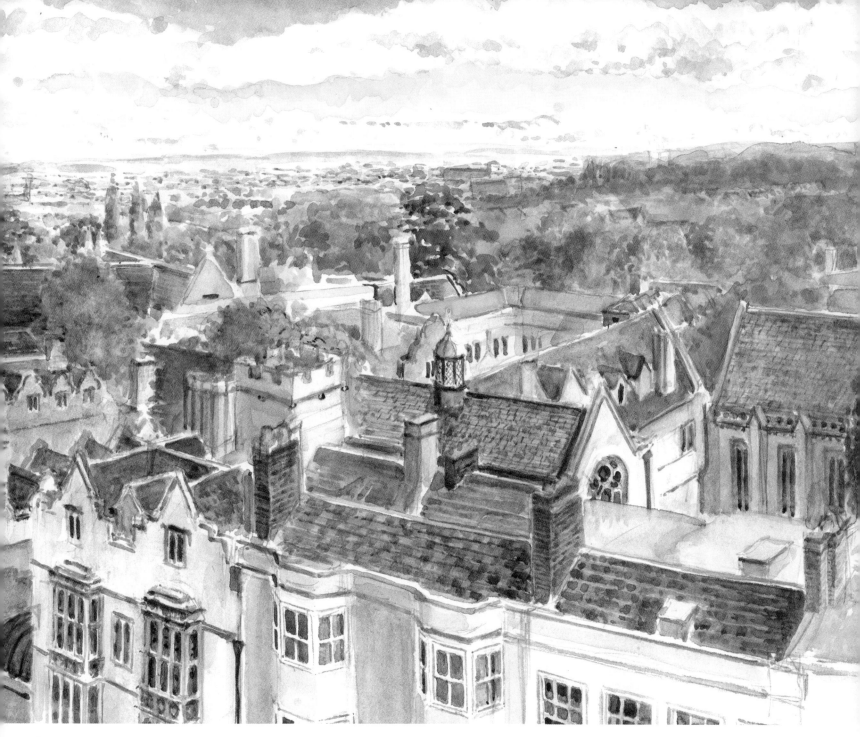

is University College, founded in 1249 by William of Durham, but only settled on this site in the 1330s, and rebuilt in the latent academic Gothic style from 1634. Beyond is the Examination School by Thomas Jackson, 1876-82 and tower of Magdalen College, completed in 1509.

On the right we have the Tudor Gothic New Building of University College by Sir Charles Barry with projecting bay windows, and 17th-century houses, now incorporated into the college. Behind is the library from 1861.

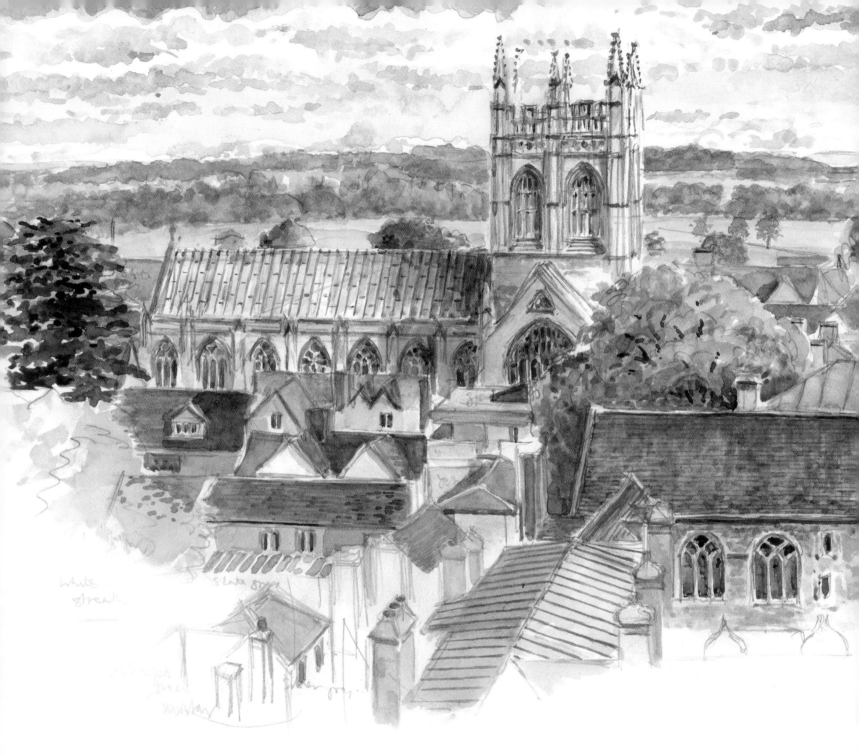

Looking directly south, the view is dominated by Merton College chapel, whose choir was started in 1290, and tower built in 1448-51. In the right foreground are the buildings of Oriel College, founded in 1326 by Adam de Brome, rector of St Mary the Virgin, but rebuilt in the 1620s. To the right is Oriel Square with the classical Canterbury Gate to Christ Church. The 13th-century tower and spire is Oxford Cathedral which serves as the chapel of the college. The colourful façades on the west side of Oriel Street are 18th century, hiding the skeletons of earlier houses.

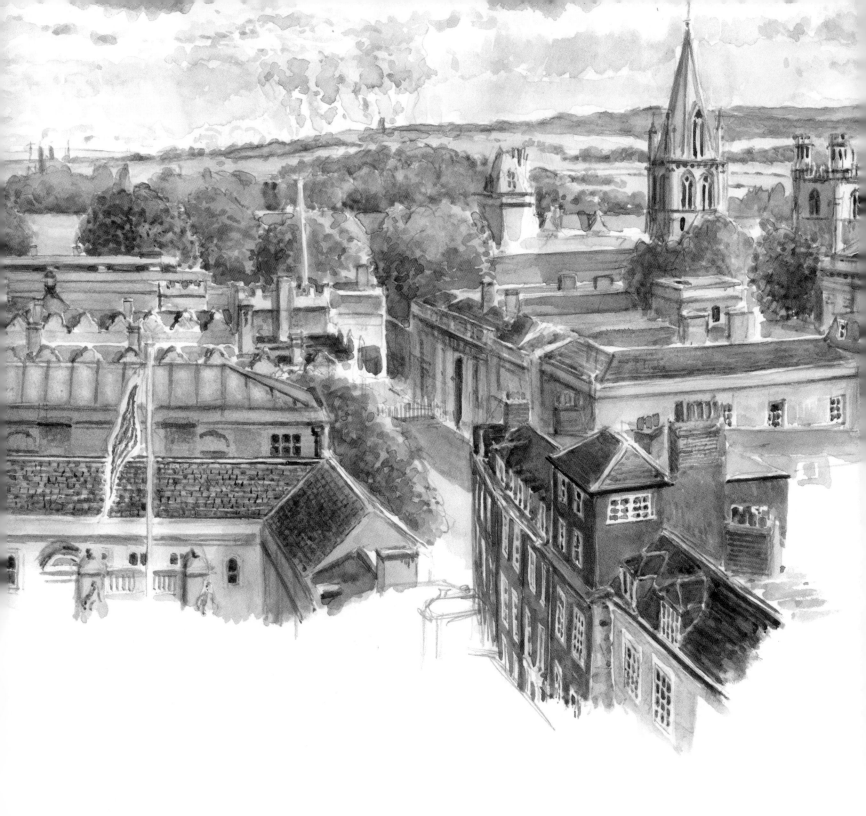

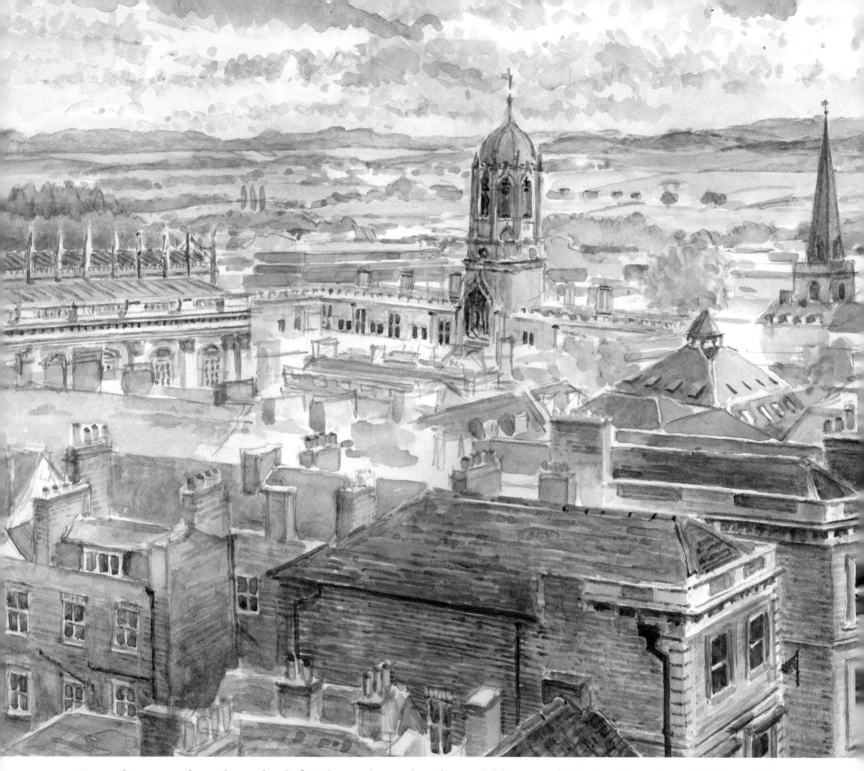

Looking south and on the left side we have the classical library of Christ Church with Wren's Tom Tower, 1681. To its right in the foreground are late 19th-century buildings in the High Street. The tower and spire belongs to the Victorian rebuilding of St Aldate's church. To the right the tall pitched roof is the hall of Thomas Jackson's Town Hall, opened in 1897. The castellated gatehouse in the foreground, 1886-89, also by Jackson, belongs to Brasenose College, built with the intention of providing an entrance

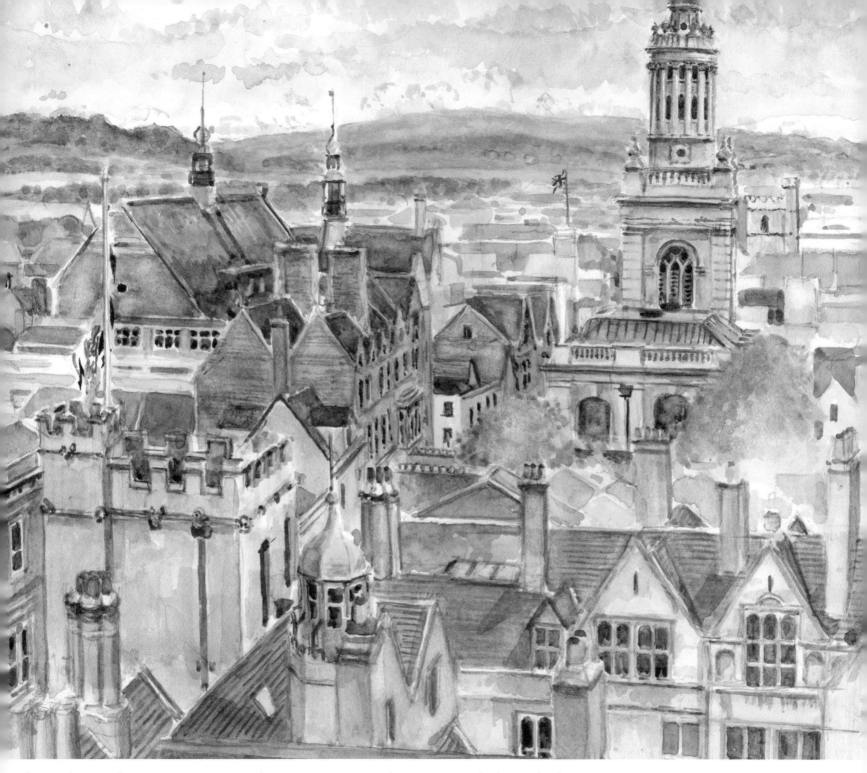

from the High Street. However, the main entrance has remained, through the original gatehouse in Radcliffe Square. The classical church of All Saints replaced a medieval one and is attributed to Henry Aldrich, dean of Christ Church. The body was rebuilt between 1706–08; the tower with its Wrenian features is a modification of a design by Nicholas Hawksmoor. The church is now the library of Lincoln College. Just to the right is the tower of St Martin, Carfax, the rest of which was demolished in 1896.

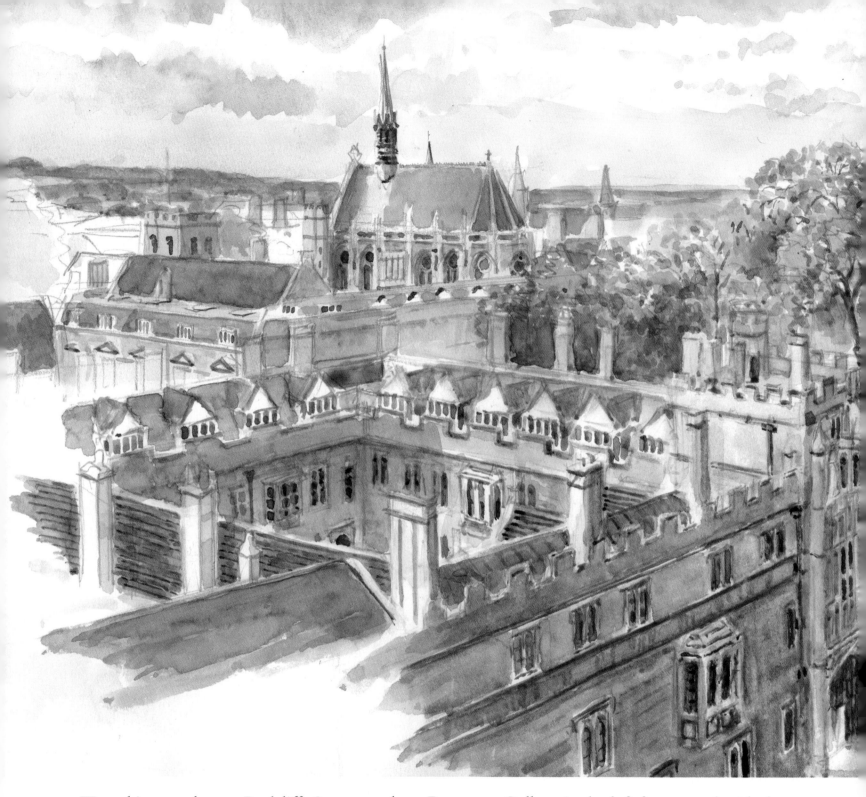

Looking north over Radcliffe Square we have Brasenose College in the left foreground with the frontage and quadrangle behind remaining as built in 1508–19. Beyond is the tall chapel of Exeter College, of 1856–59, with the trees of the Fellows' Garden to the right. The lantern of the Sheldonian Theatre by Wren peeps out between the trees and the Radcliffe Camera is seen on the right. The Camera

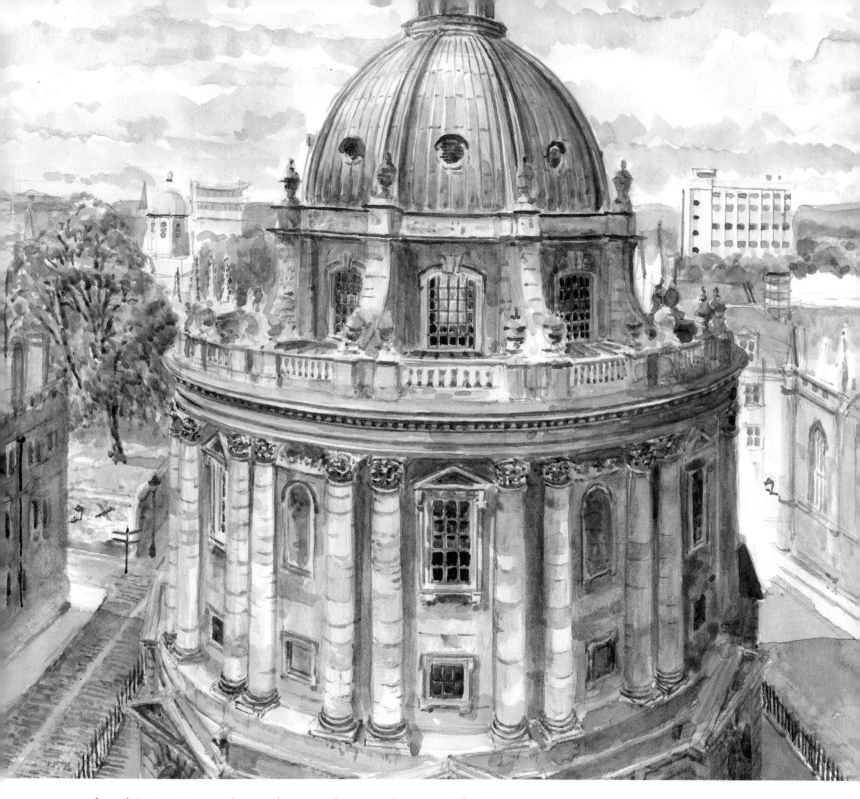

was completed in 1748 to a design by Hawksmoor but modified by James Gibbs. It was built with funds from the will of Dr John Radcliffe to house his library and scientific instruments. In 1862 it was leased to the university to become a reading room for the Bodleian Library. The ground stage, originally an open undercroft, was filled in to make a lower reading room in 1863.

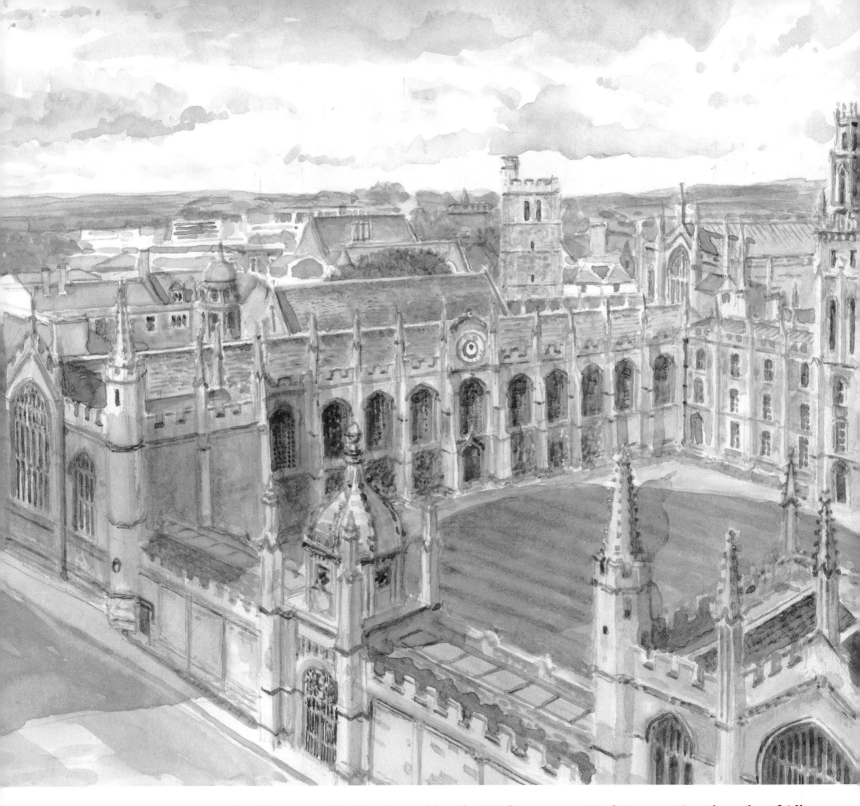

To the north-east the foreground is dominated by the 18th-century Codrington Quadrangle of All Souls College, begun in 1716. It is by Hawksmoor and adopts a loose version of the Gothic style. The interior of the library to the north side (left) of the quadrangle has a fine classical interior. In the middle bay is a sundial, said to have been designed by Wren in 1658, and originally in the front quadrangle. The

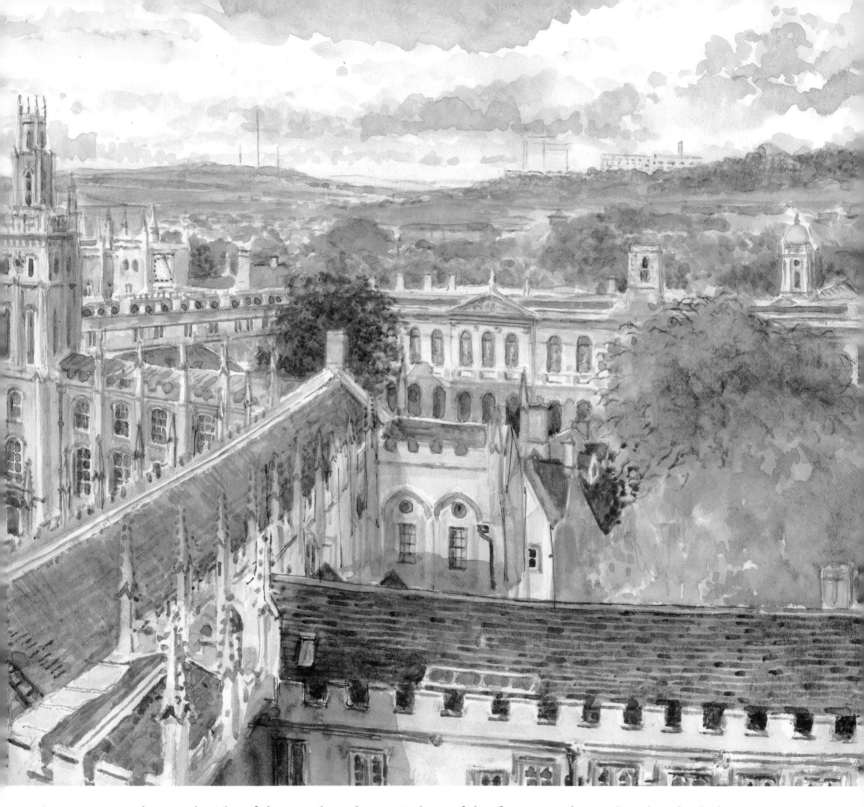

twin towers on the north side of the quadrangle remind us of the frontage of a medieval cathedral. In the centre foreground is the chapel, part of the original college, built in 1438-43. It is joined on the right by the east range containing the Old Library. Beyond the trees are the classical buildings of The Queen's College with the majestic range of its library built in 1692-95.

The City

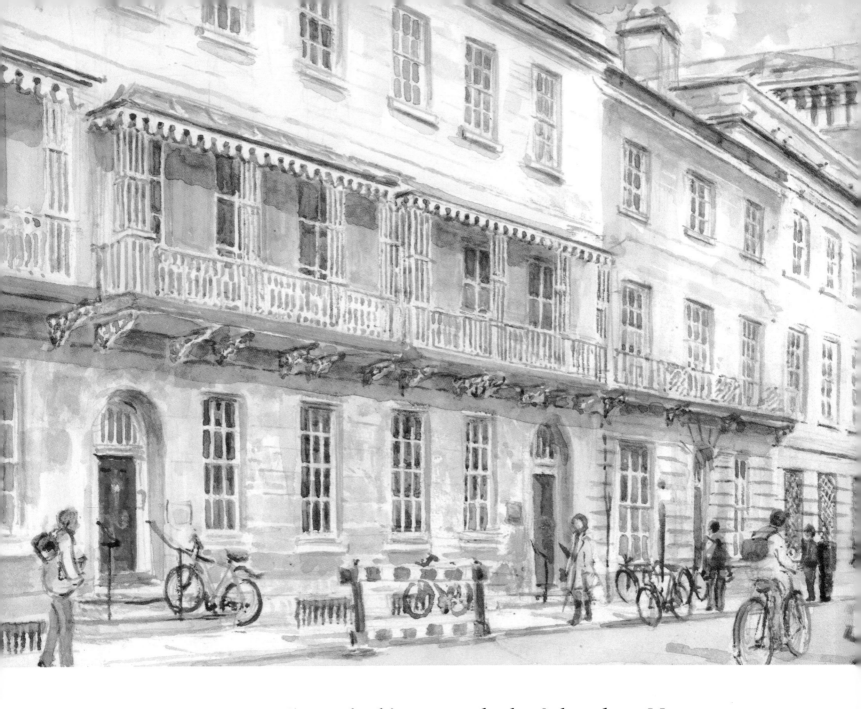

Beaumont Street: looking towards the Ashmolean Museum

The domestic architecture of Oxford is diverse, from the yellow London stock brick 19th-century terraces on Iffley Road, the red-brick 1930s semi-detached estates of Headington and Cowley, the Gothic villas of North Oxford, imitated in academic suburbs in Victorian university cities; and a drop of Bath, relocated to Beaumont Street. Although the street is a through-traffic route and consequently often very busy, it repays careful attention. It was laid out in the 1820s on land bought by St John's College in

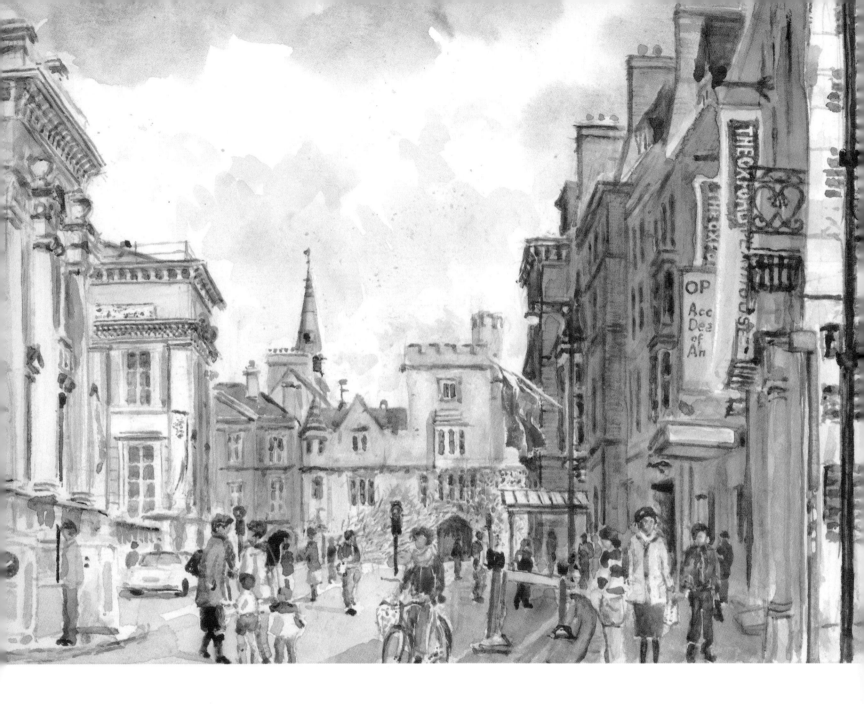

1573, to link St Giles with Walton Street. It takes its name from the royal manor house of Beaumont which stood on land at the western end in the vicinity of Worcester College. The ashlar-faced terraces are of Bath stone, some adorned with iron balconies and verandas. The side and rear walls are of red brick. Beyond the terrace is the Ashmolean Museum, founded in Broad Street in 1683 and moved to the appropriately classical building designed by C.R. Cockerell in 1843. At the end of Beaumont Street on the east side of St Giles is a 19th-century gateway to Balliol College. The Playhouse Theatre, on the south side of the street, by Sir Edward Maufe, 1938, was cleverly integrated into the existing terrace.

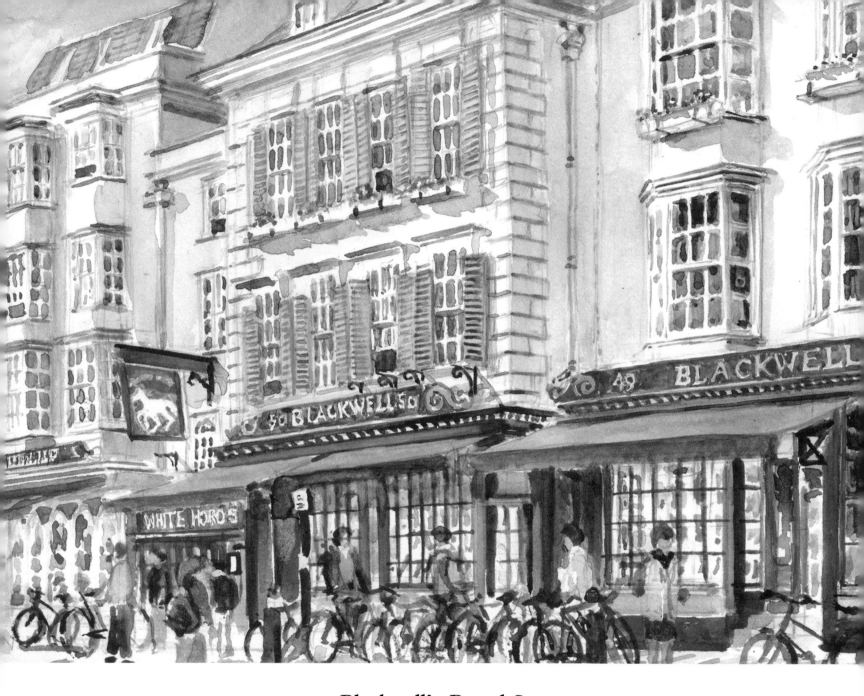

Blackwell's, Broad Street

One of the world's most famous bookshops extending deep under the lawn of neighbouring Cumberbatch Quadrangle of Trinity College, Blackwell's occupies 18th-century timber-framed houses. These have received stuccoed frontages with sash-windowed bays. The central block has added charm with its quoining and green window shutters. Here you can browse for hours with every minute adding to the temptation to buy with your 'plastic friend' and perhaps discuss your latest acquisitions over a cup of coffee on the second floor.

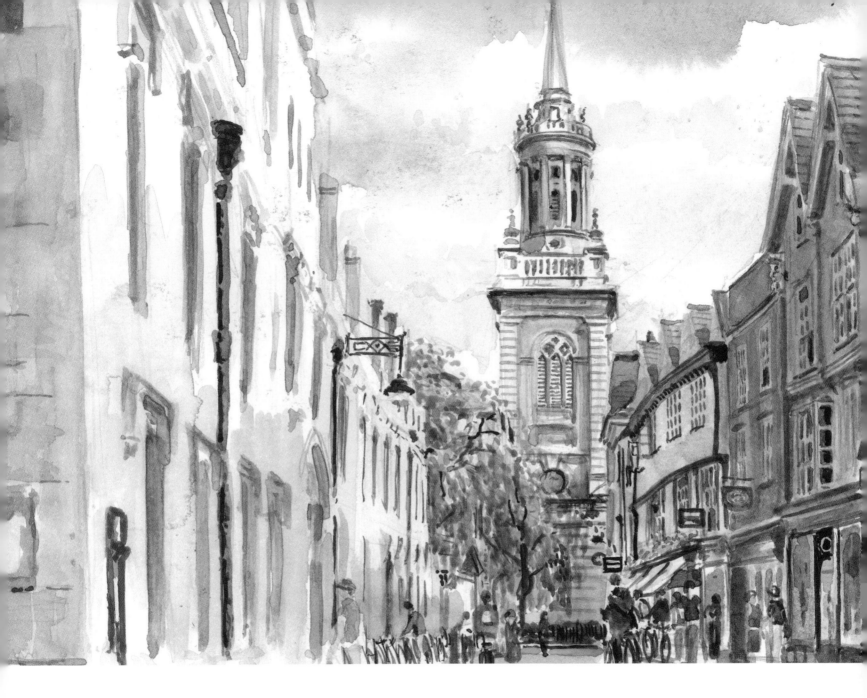

Turl Street looking south

This street in the heart of Oxford links the High Street with Broad Street. Looking south the vista is terminated by Dean Aldrich's All Saints. On the left is the façade of Lincoln College whose library now occupies the church. On the right the gabled buildings, now college accommodation, are largely 17th century with restored 19th-century façades.

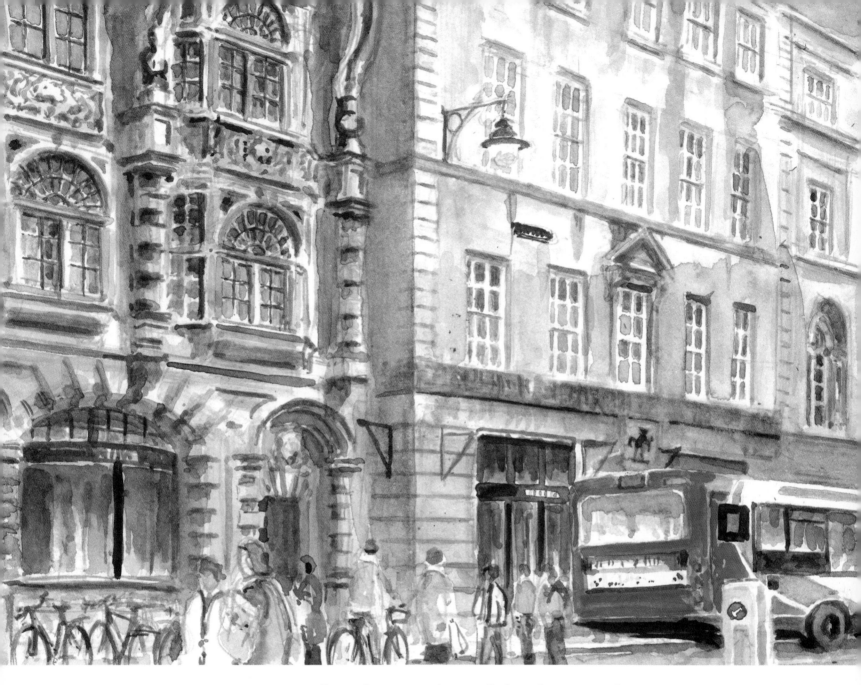

Carfax: the meeting of the four roads

This busy junction, the meeting of the four streets from the Latin *quadrifurcus* (four-forked), is where the High Street meets St Aldate's from the south and Cornmarket from the north. To the west is Queen Street, formerly Great Bailey, which was the road to Burford and Gloucester. In the centre a stone conduit was built in 1616 to supply Oxford with fresh water from springs in North Hinksey. In 1787 it was removed to Nuneham Park. In recent years the traffic has been reduced with Cornmarket becoming a pedestrian precinct and High Street being restricted to buses and taxis for much of the day. The view

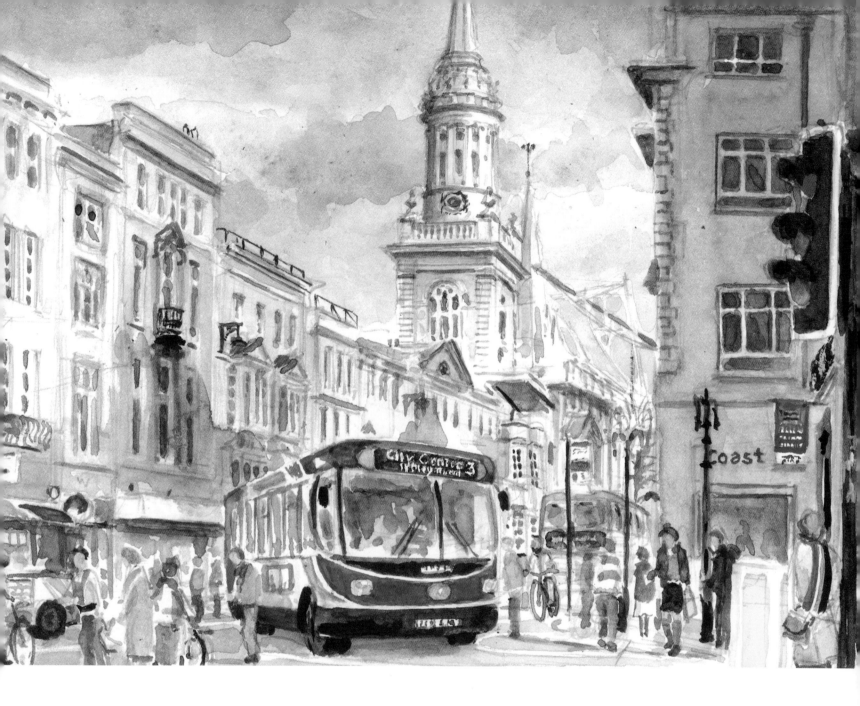

shows the north side of the High Street from Lloyds Bank in the neo-Jacobean style by Stephen Salter in 1900, through a mixture of 18th- and 19th-century façades to the tower of All Saints, beyond the Mitre Inn. Unfortunately the alignment of the south side of the High Street was set back with the redevelopment of Carfax in 1930.

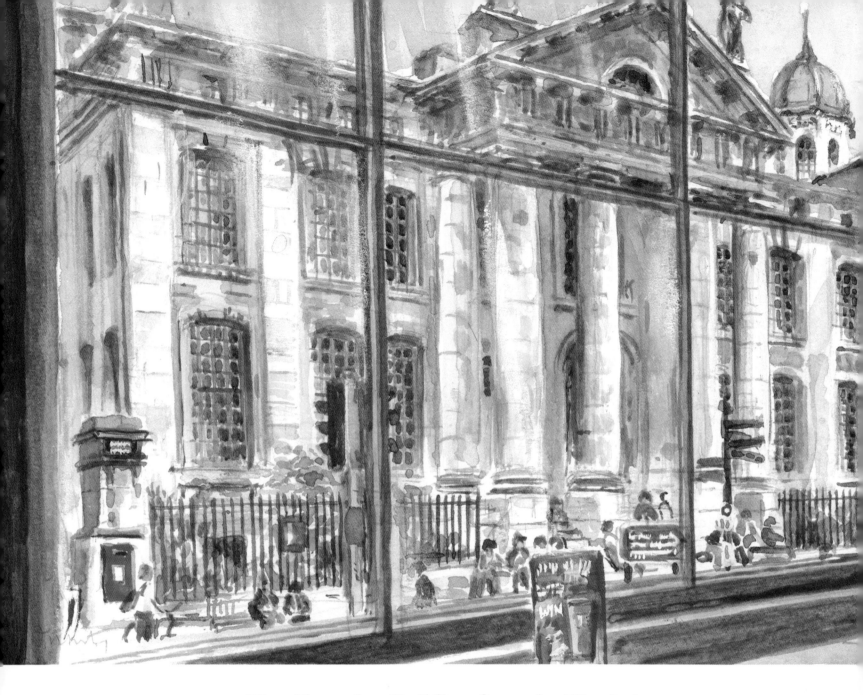

The Clarendon Building from the King's Arms

Oxford has numerous pubs known to generations of students and dons alike. J. R. R. Tolkein and C. S. Lewis used to meet regularly for many years at the Eagle and Child in St Giles, and Thomas Hardy frequented the Lamb and Flag opposite, but neither of these has such a splendid outlook as the King's Arms on the corner of Holywell Street and Parks Road. It dates from at least 1607 when Thomas Franklyn set up a sign of the 'king's arm', referring to those of James I. Its frontages were remodelled in the 18th century. Inside it is a maze of bars and rooms hung with photographs and caricatures of Oxford

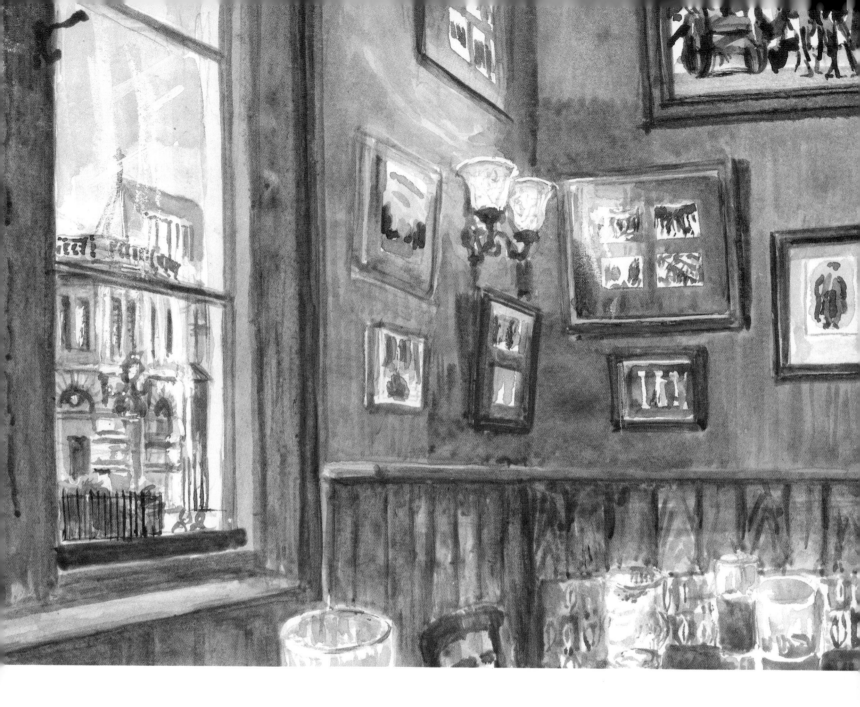

groups and personalities. It is often very crowded but those lucky enough to find a space will be rewarded by a wonderful prospect of Nicholas Hawksmoor's Clarendon Building. This is Hawksmoor's earliest building in Oxford and was built to house the Clarendon Press and University Chest. It is named after Lord Clarendon's *History of the Great Rebellion* published in 1702. Built in 1711-15, it has a giant Tuscan-ordered portico against its north front, adorned with statues of the Muses by Sir James Thornhill. The press was moved to a new building in Walton Street in 1830 and the building is now used for university administration.

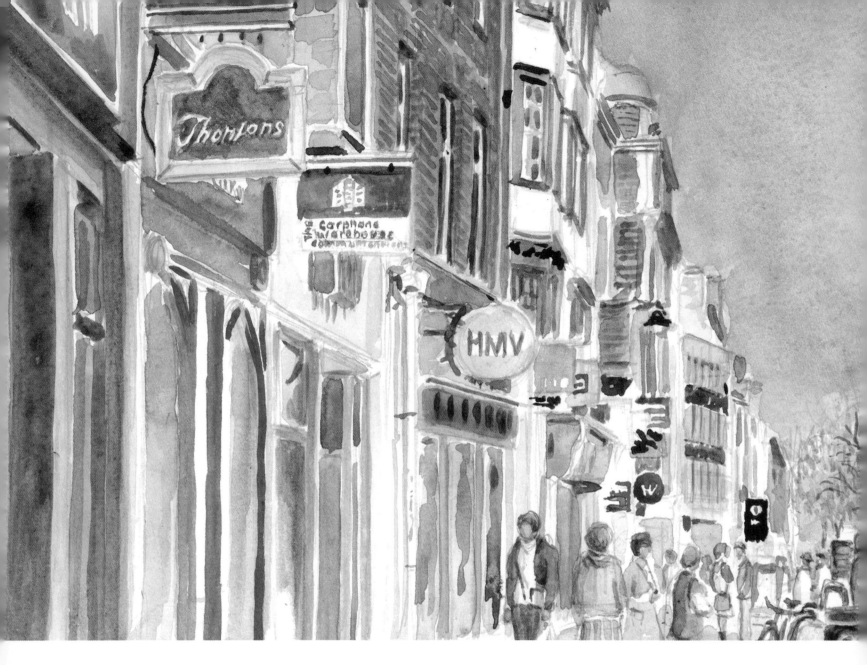

Cornmarket Street

This formed the north-south axis of the medieval city and became the main thoroughfare for the selling of corn. It ran from Carfax north to the North Gate, just beyond the church of St Michael. It was also the principal street for shops. Many tailors, hatters, shoemakers and other trades would manufacture the goods in a workshop behind a frontage perhaps no wider than ten feet. There were also numerous inns including the Golden Cross which may have originated in the 12th century. Its surviving north range is of around 1540, and is set within a narrow yard which is full of character and is entered through an arch from Cornmarket. In this picture the half-timbered building was originally the New Inn built in about 1390. Over the centuries it has suffered considerable disfigurement, finally being all but hidden behind a flat

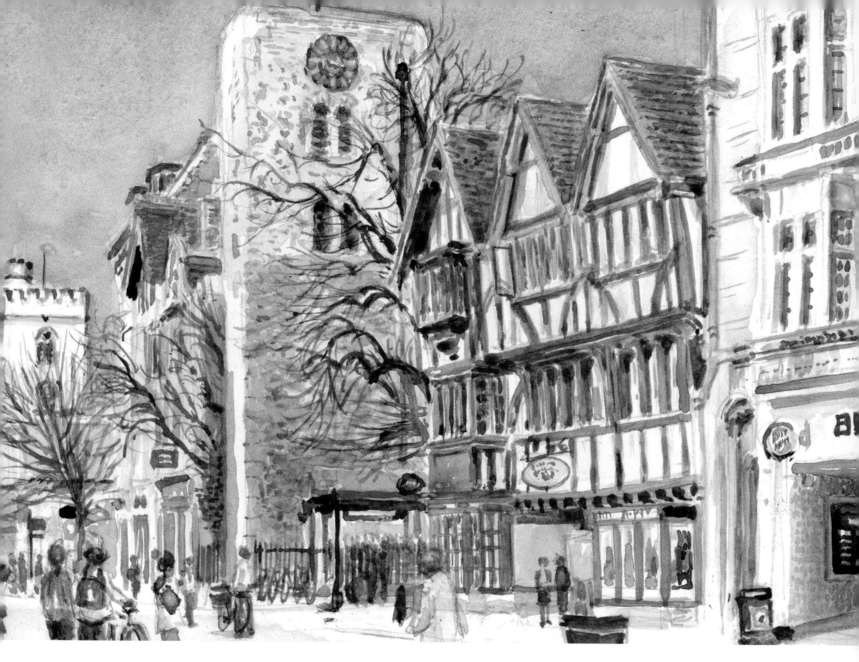

façade. It was restored between 1950 and 1985. Its appearance must have been typical of many buildings in Cornmarket Street before the 19th century. Like major thoroughfares in other cities, many small properties were pulled down to make way for characterless slabs which have sadly disfigured much of the street, as much by their scale as appearance. There are, however, several gems which survive including a 17th-century timber-framed house at the corner of St Michael's Street. The limestone tower of St Michael's church is late Saxon and has distinctive long-and-short work clasping the corners and paired openings which are divided by bulbous columns. The church was rebuilt in the 14th and 15th centuries. The North Gate, demolished in 1771, contained the gaol called Bocardo on its upper floor. Here Archbishop Cranmer and Bishops Latimer and Ridley were confined before being burnt at the stake in October 1555 in nearby Broad Street. The tower in the distance is that of St Mary Magdalen, built in the 16th century.

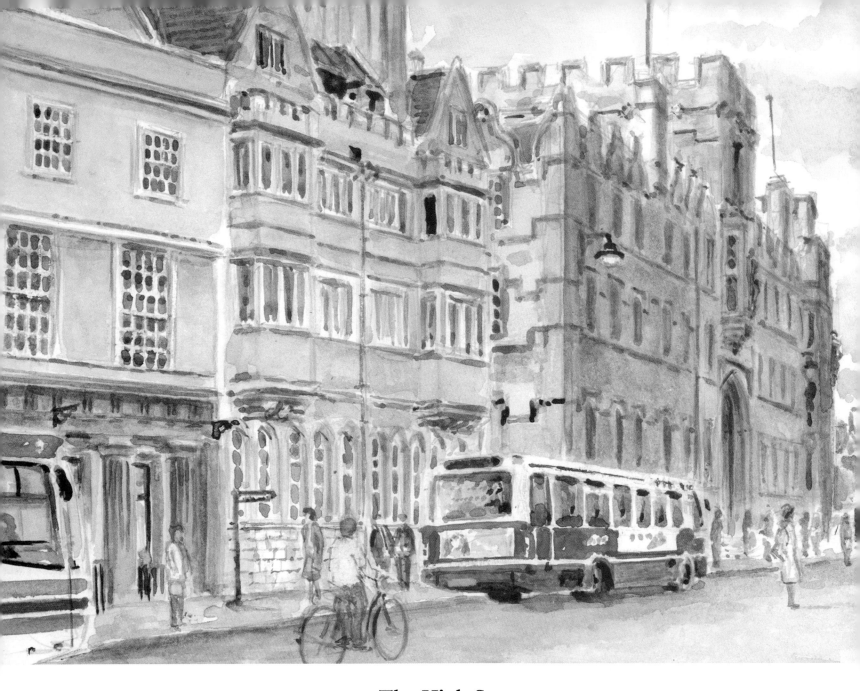

The High Street

This view, familiar throughout the world, captures the architectural quality of the street with its subtle curve. Until recently the volume of weekday traffic allowed little opportunity for the photographer or artist to get an unhindered view. Now access is restricted to buses, taxis and cyclists. Starting on the left side we have the plaster-clad façade of a bank; the Doric columns are 19th-century. Next is a block from 1902 for University College but built in the 17th-century style. Beyond the bus we see the crenellated façade frontage of Radcliffe Quad built in about 1715. Dr John Radcliffe, a fellow who gave £5,000 for its construction, insisted it be in the Gothic style. The right-hand side of the street provides a striking contrast

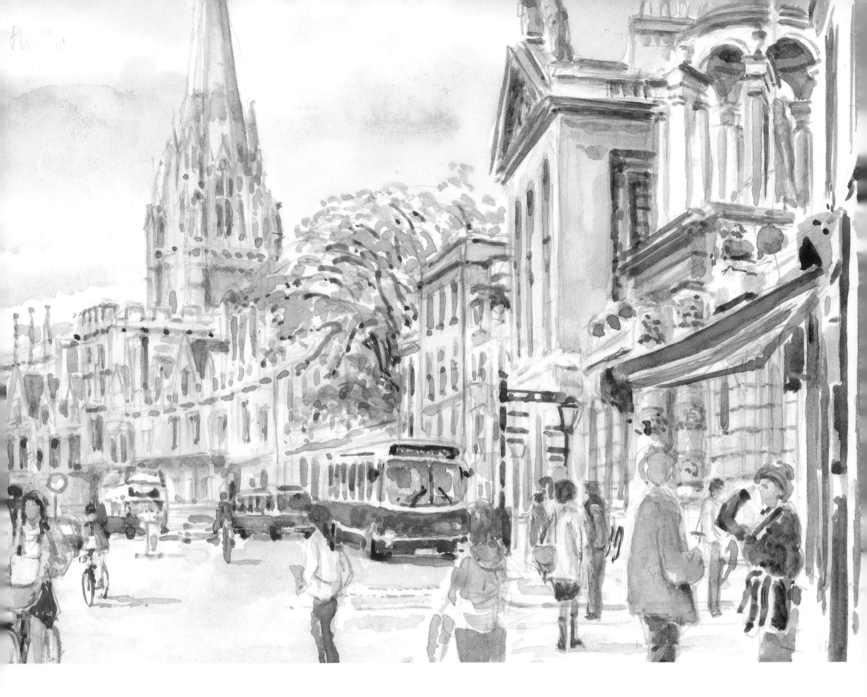

with the classical frontage of The Queen's College immediately beyond the green blind of the coffee house. The white cupola shelters a statue of Queen Caroline of Ansbach from about 1727. Beyond the tree we have the frontage of All Souls which survived plans for rebuilding in the classical style by Hawksmoor: this was fortunately dropped and Hawksmoor's work, grand as it is, was confined to the Codrington Quadrangle to the north of the original buildings. The tower and spire of St Mary the Virgin of about 1315-25 makes a grand contribution to the skyline before the classical steeple of All Saints comes into view as one advances along the High Street.

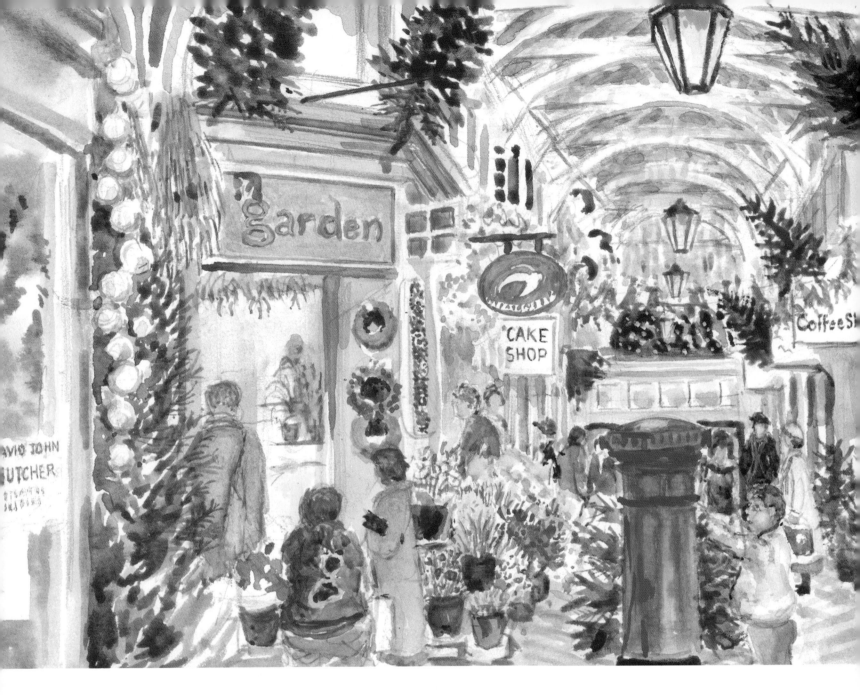

Oxford Market

Like all ancient market towns the stalls were originally in the main streets including High, Cornmarket and Queen Streets (formerly Butchers Row). In the 1770s as part of the town improvements, John Gwynn was commissioned to build a covered market between the High Street and Market Street, and with a range on the High Street of stone containing four houses with a central pediment. The market was rebuilt in the 1830s and again in the 1890s which is the date of the present roof. With stone flags on the floor and elegant shop fronts it retains the character of a Victorian market, especially at Christmas-time.

Parks Road and Wadham College

Looking up Parks Road from the corner of Broad Street on a summer's day, the viewer might feel he or she is looking into open country. Indeed this area was open fields until the 18th century, apart from Wadham College and the garden of Trinity College. This viewpoint is reversed in this picture looking towards the junction with Broad Street, with Hertford College beyond. The frontage of Wadham conveys the impression of a medieval foundation with a crenellated tower above the entrance. Architecturally it demonstrates the way Gothic was preferred for college buildings until well into the 17th century. The college was founded in 1610 on the site of a dissolved Augustinian friary by Dorothy Wadham with money

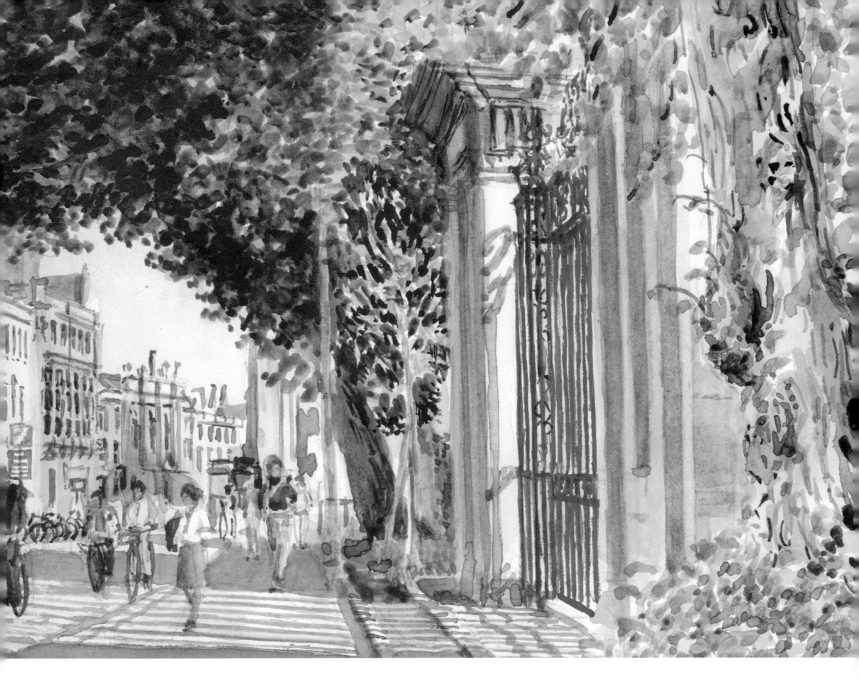

left by her husband, a Somerset landowner, for endowing a college for students from the West Country. Although she was a Roman Catholic, it was to be staunchly Anglican with an emphasis on strict attendance at chapel twice a day. She appointed William Arnold as master mason, who had worked on Montacute House. The college was completed in three years although Lady Dorothy never visited Oxford to see it. The centrepiece is similar to that of the Fellows' Quadrangle at Merton with paired, super-imposed classical orders enclosing niches filled with a statue of King James I, and beneath, Nicholas and Dorothy Wadham. The college quickly attained fame as a centre for scientific experiment under Warden John Wilkins. Among students in the Wadham Philosophical Society was Christopher Wren. On the right is a gate to Trinity College gardens laid out under President Ralph Bathurst, probably in the 1680s.

The Colleges

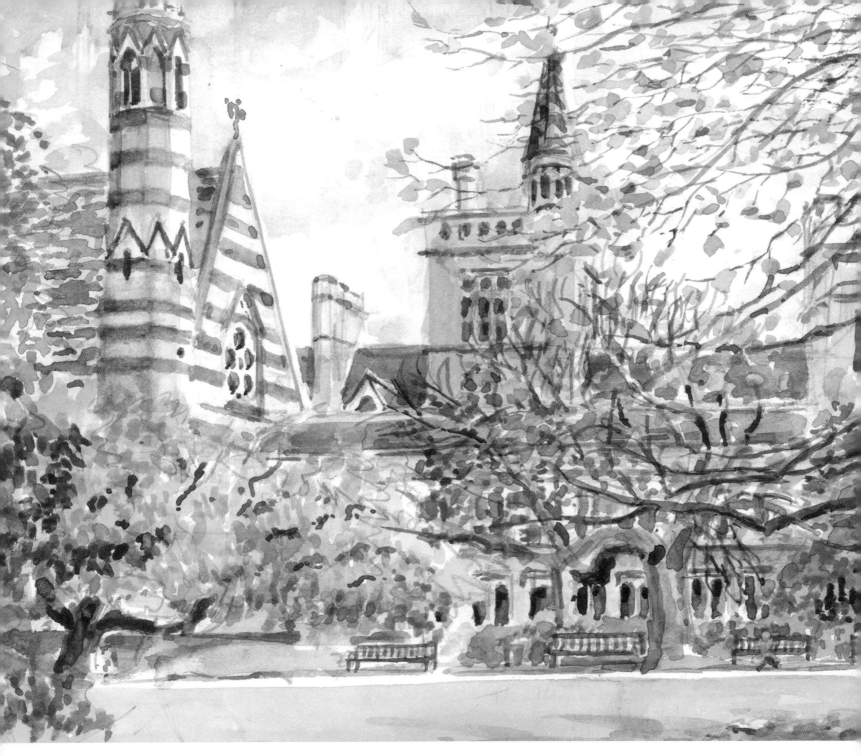

Balliol College: autumn afternoon

Michaelmas Term begins in early October, and, in a good year, starts with a few weeks of strong sunshine which enhances the autumn colours. In a bad year, however, there may be days when the fog rolls in from the Thames and Cherwell valleys, or fierce gales which quickly strip the trees of their leaves. If Balliol is not renowned for its buildings, it certainly makes up with its trees which help to make

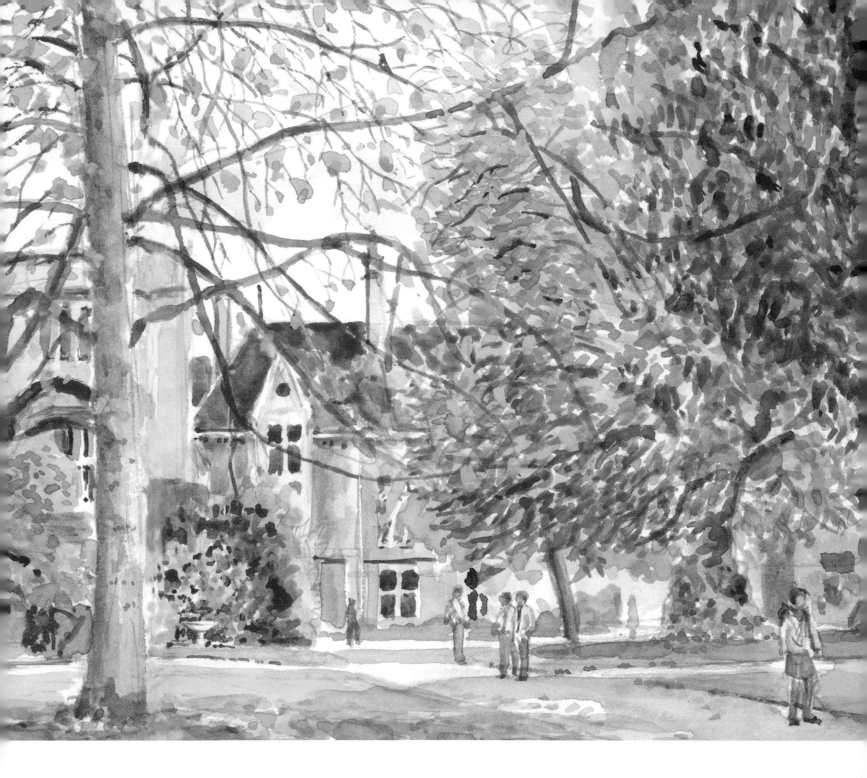

the college seem even larger. Although founded by John Balliol, a northern baron, as a penance for having captured the bishop of Durham in the 1250s, his wife, Lady Devorguilla of Galloway, gave the college a permanent endowment and a foundation charter in 1282. It was a small college until the 19th century when it was almost wholly rebuilt. It attained an academic supremacy under Benjamin Jowett, a classicist and theologian, and master 1870-93.

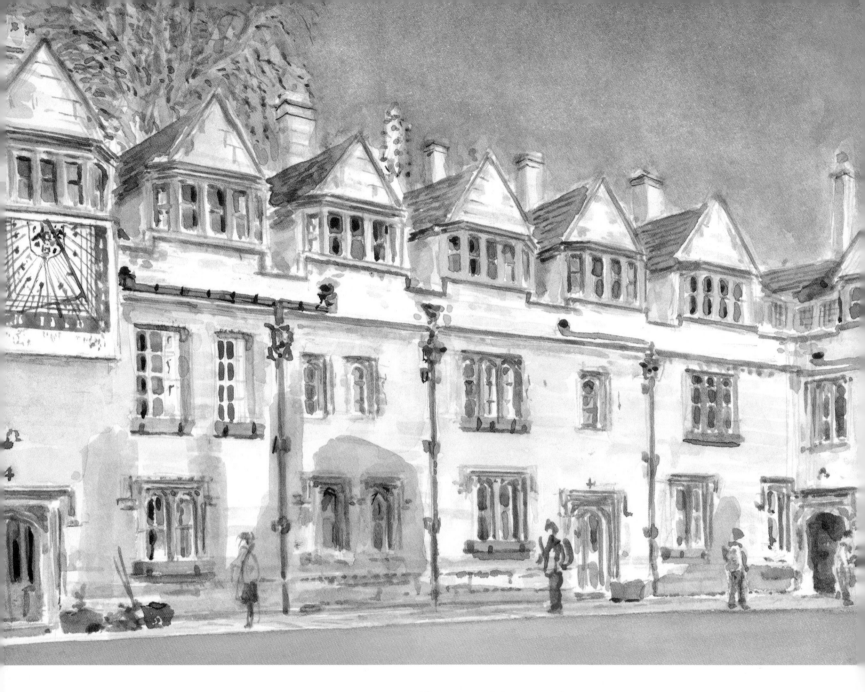

Brasenose College: Old Quadrangle

This is a familiar view of Brasenose with the Radcliffe Camera rising beyond the gatehouse, and was painted by Turner for the *Oxford Almanack* in 1805. Founded in 1509 by William Smith, bishop of Lincoln and a lawyer, it takes its name from Brasenose Hall which stood on the site of the college. This quadrangle was begun in 1509 and, apart from the attic gabled storey added in around 1605, remains as built. The gatehouse is particularly impressive with the upper chamber richly ornamented with scroll-like tracery. The second chamber above the roof-line is flanked by an octagonal stair turret leading to the battlemented parapet. The north range (left side) has an impressive sundial, set up in 1719.

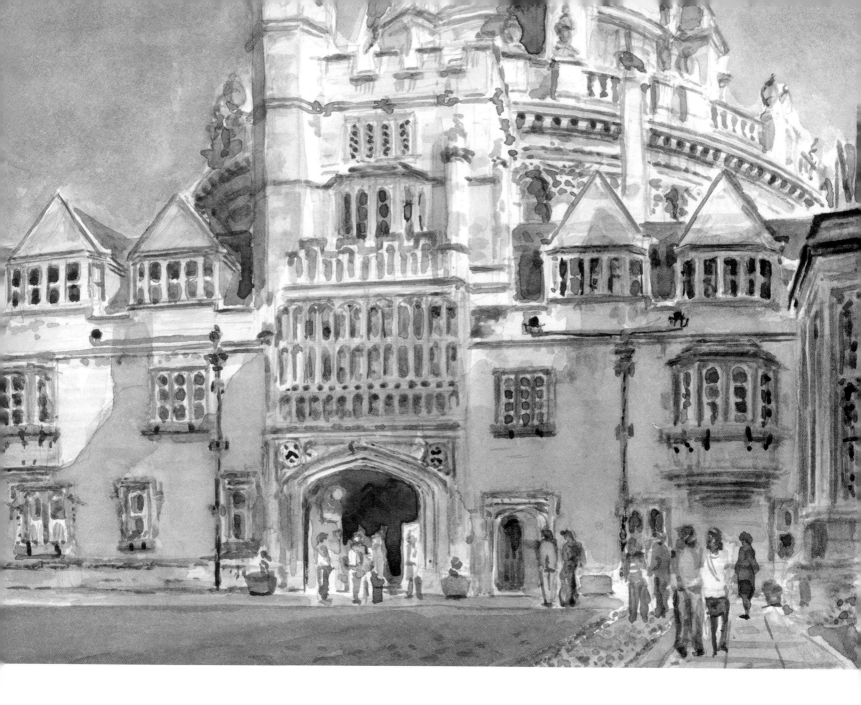

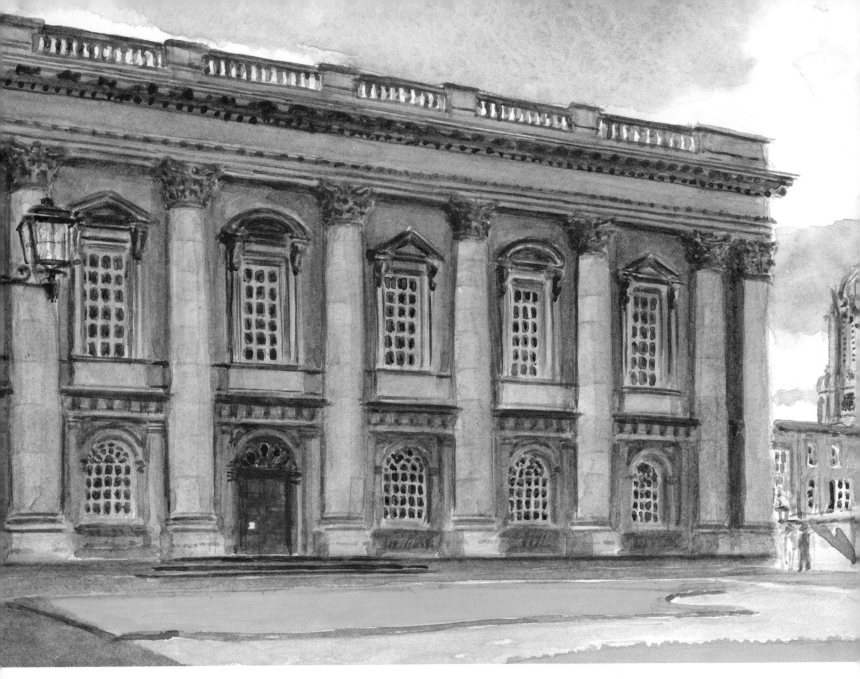

Christ Church: Peckwater Quadrangle

The feeling for the grand reaches its climax in Peckwater Quadrangle which was built in 1707-14 to the design of the then dean, Henry Aldrich, who numbered architecture among his various talents. In many respects, the three sides of the residential ranges have the air of a Bath terrace, nearly a decade before Wood the Elder began transforming that now magnificent town. Each range is marked by a pedimented centrepiece with giant-ordered Ionic half-columns above on a rusticated base. The windows of the *piano nobile* are surmounted by alternating triangular and semicircular pediments in the Italian manner. The quadrangle is completed on the south side by the detached library (left) started in 1717 with a legacy

46

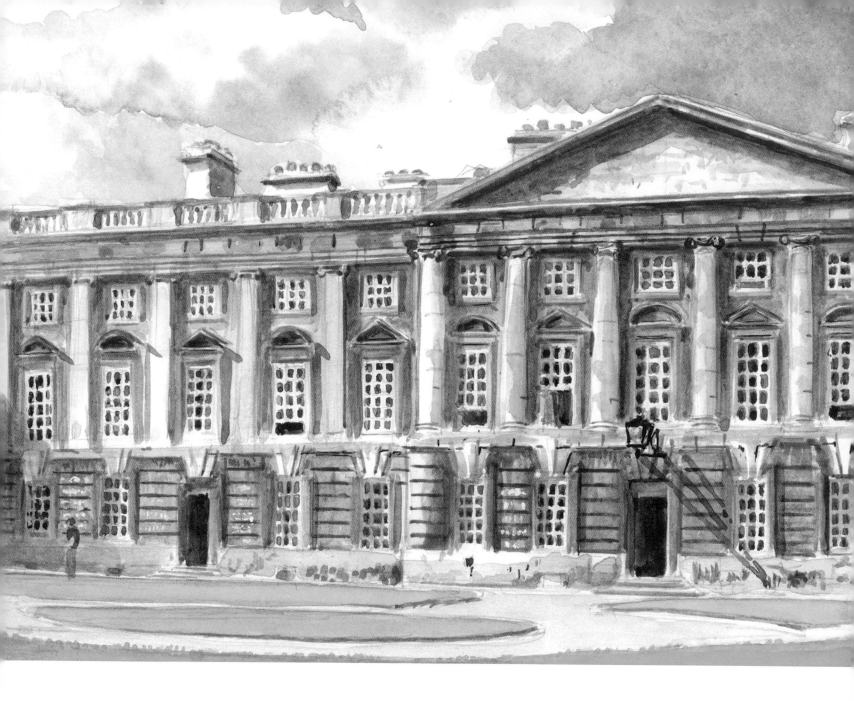

of £500. Initially by Aldrich, the design was modified by Dr George Clark 'to make it the finest library that belongs to any society in Europe'. It owes much to the design of Michelangelo's Capitoline Palace in Rome, where the lower or ground arcade remains open on three sides. Here the library, as elsewhere, was to be on the upper floor, but in 1769, the ground floor was enclosed to house the art collection, now exhibited in the neighbouring gallery in Canterbury Quadrangle. The façade of the library is divided by Corinthian giant-ordered half-columns, paired at the corners. An added quality is the contrast between the Portland and Taynton stones.

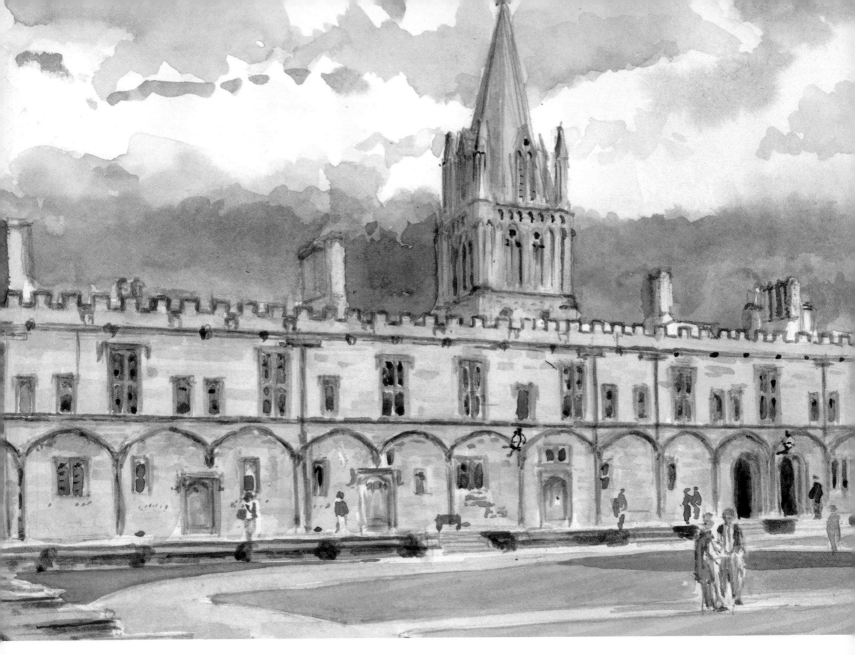

Christ Church: Tom Quadrangle

There is something grand, yet austere about Christ Church. It has not the intimacy of a small college like Lincoln or Jesus. It proclaims itself as its original founder, Cardinal Thomas Wolsey, intended, the largest of all colleges. Entry through the main gate beneath Tom Tower reveals a large but unfinished quadrangle. The walls have the markings for the intended cloister which would have made it more intimate. The college, originally known as Cardinal College, was founded in 1525 on the site of the dissolved priory of St Frideswide, but Wolsey's grand intentions were cut short by his fall from power in 1529. The college was then taken by Henry VIII who re-founded it as Christ Church in 1546 but failed to provide enough money for its completion. The intention was for the hall on the south side to be balanced on the north by a

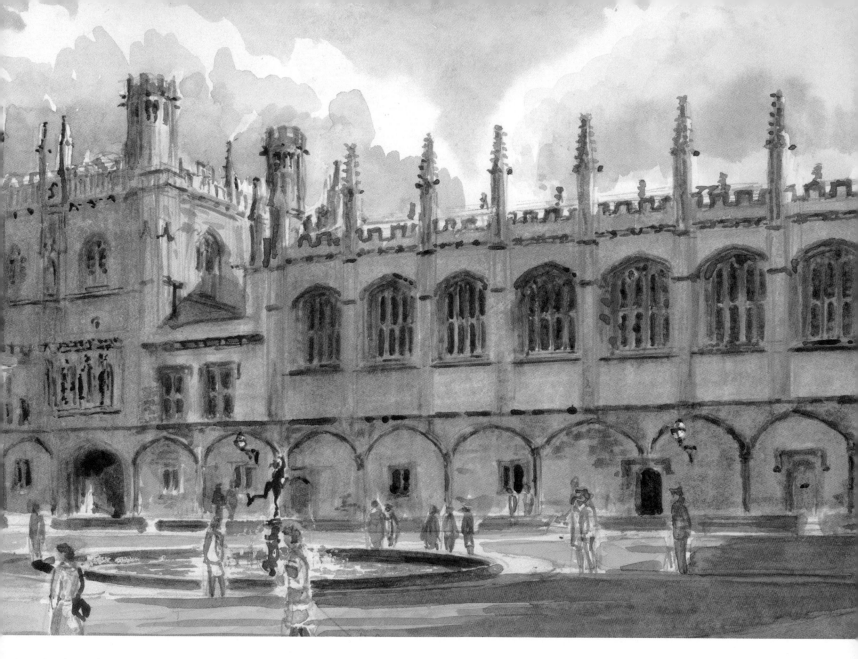

huge chapel which might have rivalled that of King's, Cambridge. When completed, the temporary chapel, formerly the priory church, which remains as Oxford Cathedral, was to have been demolished. It was not until the 1660s that the north range of Tom Quadrangle was completed over the footings for Wolsey's demolished chapel. In 1680 Wren was commissioned to finish the gateway with one of his few essays in Gothic, the octagonal belfry topped by an ogee dome to house the former bell of another dissolved foundation, Osney Abbey. The centre of the quadrangle is marked by a fountain with a bronze cast of Mercury by Giovanni da Bologna. We might reflect on the many well-known figures who frequently walked beneath Tom Tower including Albert Einstein, a research student (fellow), 1931–33; Charles Dodgson, lecturer in mathematics, 1856–81, who wrote *Alice in Wonderland* for Alice Liddell, daughter of the dean; writer W.H. Auden; and actor Norman Painting (Phil in *The Archers*), a research student in the 1940s.

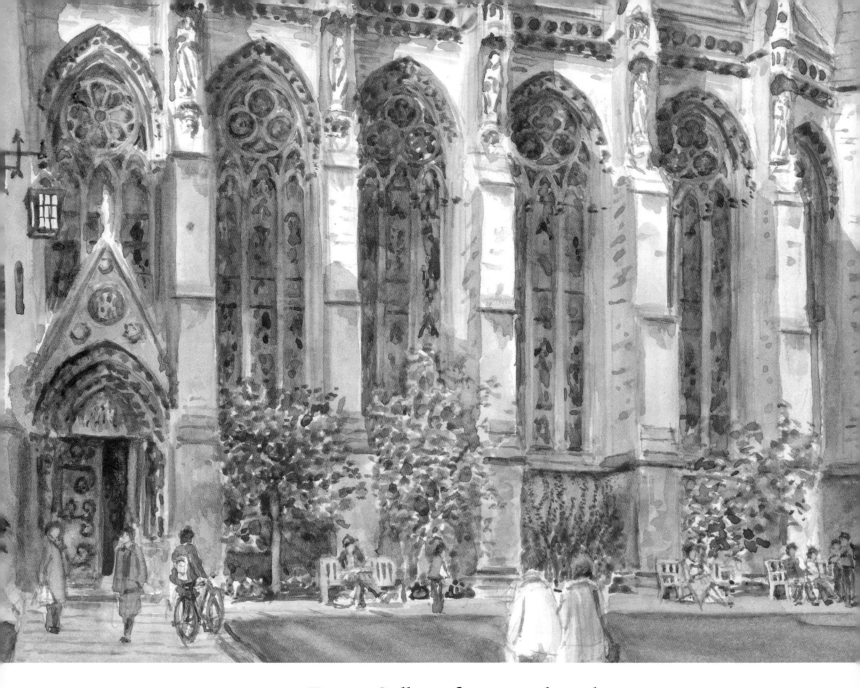

Exeter College: front quadrangle

Founded as Exeter Hall in 1314 by Walter de Stapeldon, bishop of Exeter for training twelve students in theology, the college remained small until a major donation by Sir William Petrie in 1566 led to substantial rebuilding when it was renamed Exeter College. The only medieval building surviving is Palmer's Tower, directly east of the chapel, built during the rectorship of William Palmer in the 1430s. Entry through the 1830s gatehouse from Turl Street leads us into a small quadrangle with the 1708 Armagh Building on the east, and hall from 1618 on the south. The most spectacular building, however, is the chapel, rebuilt in 1856-59 by George Gilbert Scott to replace one from the 17th century. It is reminiscent

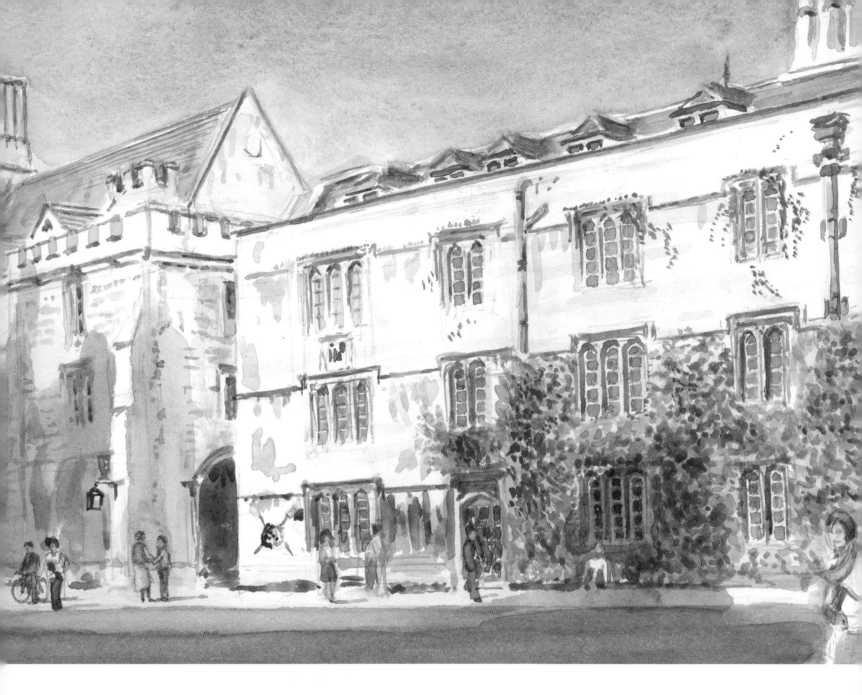

of the 13th-century Sainte-Chapelle in Paris. Some feel it to be too big for its setting but Scott originally intended it to be entered by a west door directly in line with the gatehouse. The tall three-light windows flanked by boldly projecting buttresses are filled with Clayton and Bell glass, making the interior rather sombre. Nonetheless, it is one of the most atmospheric monuments of the Victorian age among Oxford colleges. It is vaulted with ribs springing from coloured marble wall-shafting and the coloured stone vault panels are left, as in the French manner. The elaborate stalls and canopies are by G. F. Bodley. On the south side of the chancel is the Morris tapestry of the *Adoration of the Magi,* designed by Burne-Jones. The college numbers William Morris and Edward Burne-Jones among its alumni.

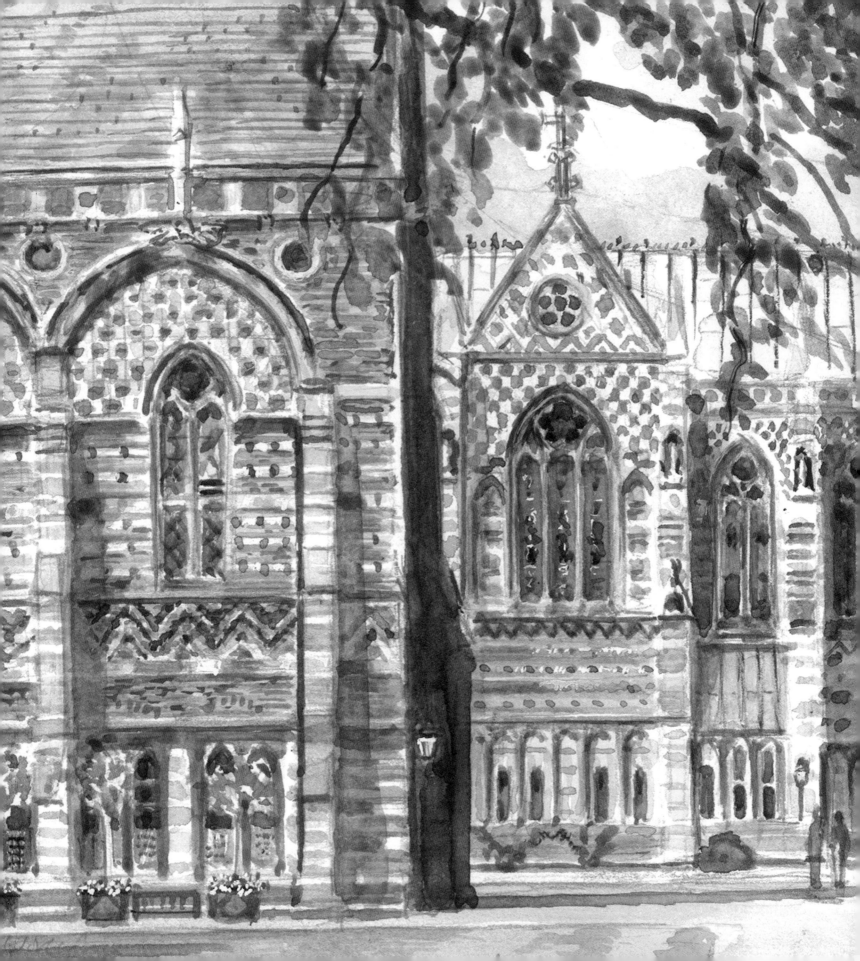

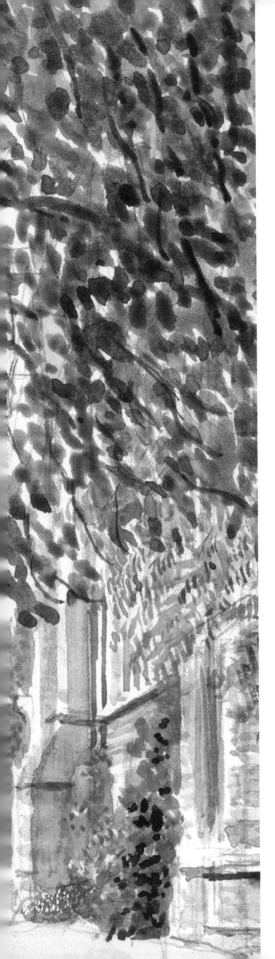

Keble College

Until the 1960s Keble was considered something of an architectural joke with its vivid polychromatic brickwork. There was even an undergraduate society pledged to its demolition; but today it is prized as one of the finest examples of 19th-century British architecture. It was founded in 1868 and named in memory of John Keble, a founder of the High Church Oxford Movement, for the training of gentlemen of modest means principally for the Anglican ministry. An appeal was met with a large donation of £50,000 from William Gibbs of Tyntesfield near Bristol, and the college was virtually complete by 1882. The architect was William Butterfield, who had earlier designed Balliol College chapel as well as All Saints, Margaret Street in London. He was a master of polychromatic brickwork which suited the college building budget as it could not run to stone buildings on such a scale. The college broke with tradition in that students lived in rooms on corridors rather than 'on' staircases.

The main buildings are built round Liddon Quadrangle which is dominated by the chapel on the north. Here Butterfield's 'permanent polychrome' is shown to the full with red brick interspersed with horizontal bands of chevron patterning in yellow and black brick. The chapel, which dwarfs the domestic ranges, was considered by the architectural critic Goodhart-Rendel to be 'possibly one of the three or four buildings in Oxford of most architectural importance'. It almost dazzles with the red and cream chequer-work patterns in the gables and above the windows. The interior broke with convention in having the pews facing the altar rather than being placed facing one another as in all earlier college chapels. The library in the foreground is above the Senior Common Room and is also a remarkable display of brick patterning. The library furniture is also by Butterfield. Although the college still has a strong tradition for theological studies, it is open to undergraduates of many disciplines and has built up a tradition for producing rowing blues.

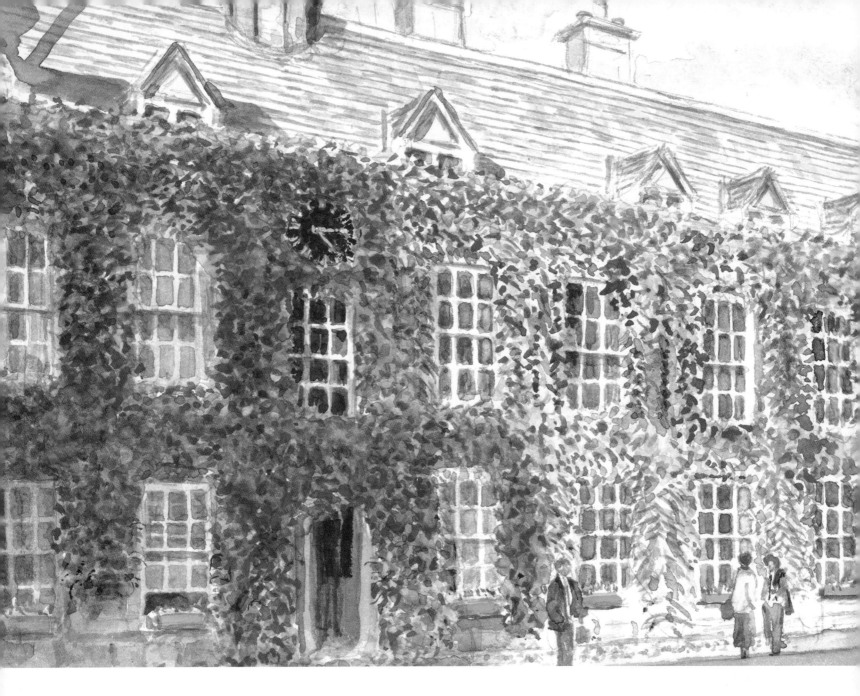

Lincoln College: front quadrangle

The front quadrangle on an autumn day is a visual joy as the creeper changes its hues. Also the grass is a deep green, perhaps the finest in Oxford. Added to this, the college has an intimacy missing from larger ones. Lincoln was founded by Richard Fleming, bishop of Lincoln, in 1427 and helped by a substantial bequest from John Forest, dean of Wells. What we see is a quadrangle from the 15th century although the windows are sashes, probably fitted in the 18th century. The north range (left) originally

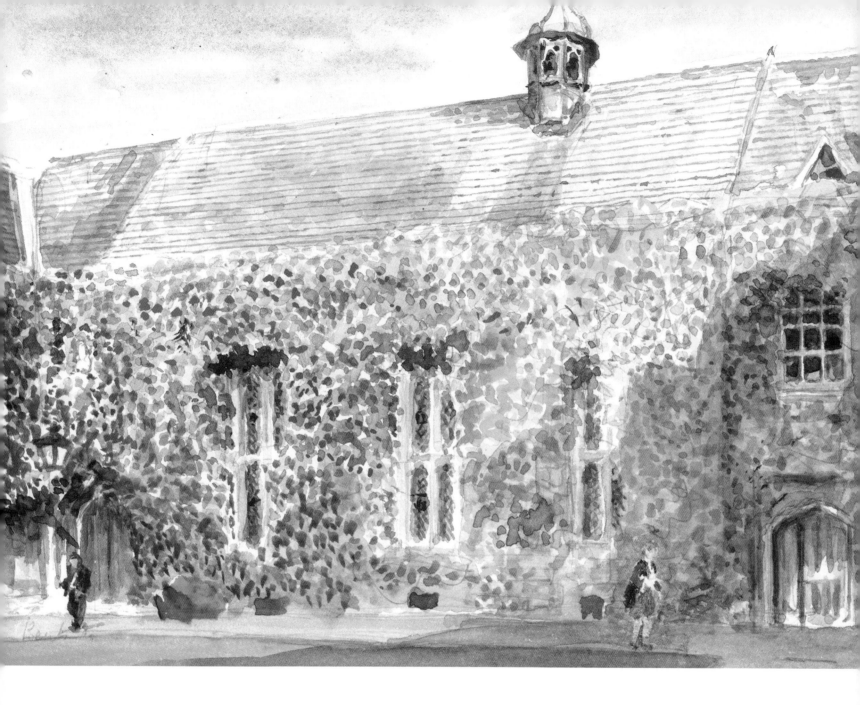

contained the library on the first floor, as well as the first chapel until a new one was built on the south of Chapel Quadrangle in 1629-31. Opposite the entrance is the hall with three tall mullion- and transom-windows to the left of the doorway to the screens passage. The kitchen is beyond this passage. The roof has a replica of the original louvre which allowed the smoke to escape from the open hearth beneath.

Magdalen College: New Building from the park

The grounds of Magdalen can hardly be described as a college garden; they include a deer park as well as an island enclosed by branches of the Cherwell. They are so extensive that it is easy to feel one is on the edge of open country. The path on the left is Addison's Walk, named after the essayist, poet and politician and a fellow between 1698 and 1711 who liked to walk here. On the right is the New Building, 1733-34, intended to form part of a vast new quadrangle linked to the 15th-century buildings. It was

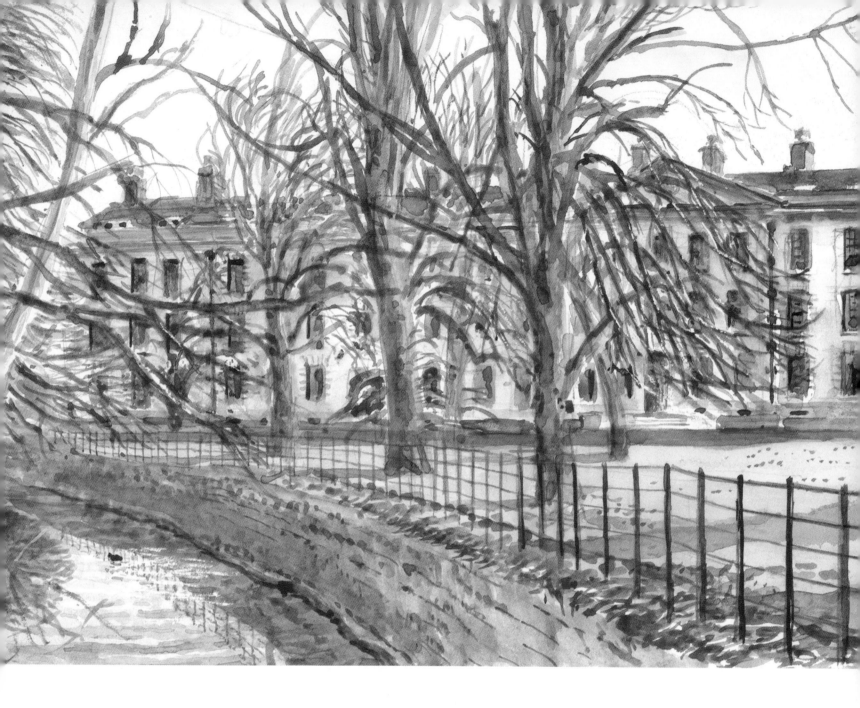

probably designed by Dr George Clarke. Fortunately it has been left as an isolated range of twenty-seven bays with a slightly projecting pedimented centrepiece. There was even a plan to Gothicise it in the early 19th century and link it to the medieval buildings. Undergraduates who subsequently made a name in English literature include Edward Gibbon, Oscar Wilde, Compton Mackenzie and John Betjeman.

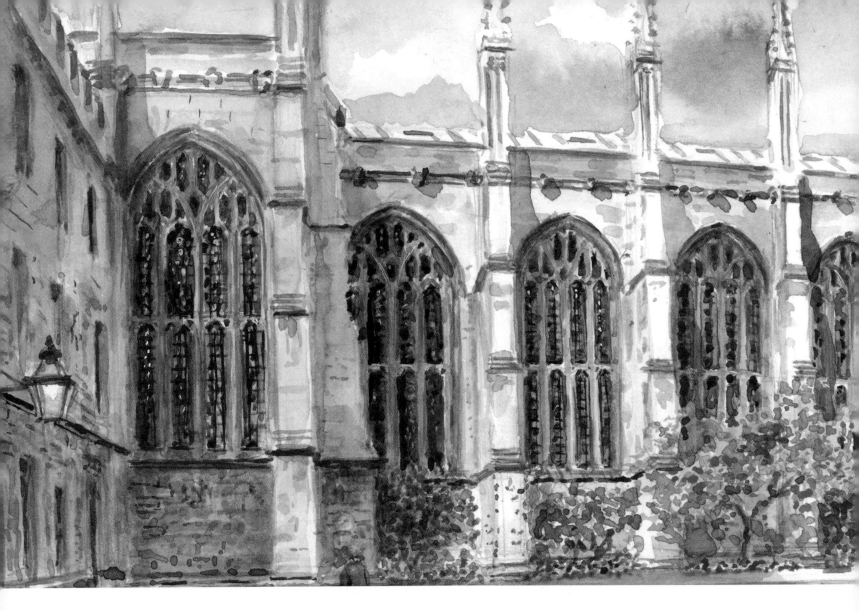

New College: quadrangle

The core of New College remains as completed by about 1400, the only addition being a third stage on the three residential ranges added in the 1670s. When the founder, William of Wykeham, bishop of Winchester, sought land within the town to found a college in the 1370s, the only site available was just within the north-east corner of the wall adjacent to houses, vacant perhaps since the Black Death, and on land used as a rubbish tip. The college was to be a sister to his other foundation, Winchester College: both were dedicated to the Virgin Mary, and with a similar plan of a quadrangle entered through a gatehouse with one side given to the hall and chapel, end to end. The mason-architect for both was William Wynford. The chapel was begun in 1380 with the intention of having a chancel of five bays and a three-aisled nave. However, this ambitious plan was dropped when the land to the west was acquired and developed as a cloister. So the two western bays (one shown in picture) were to become an ante-chapel and the building

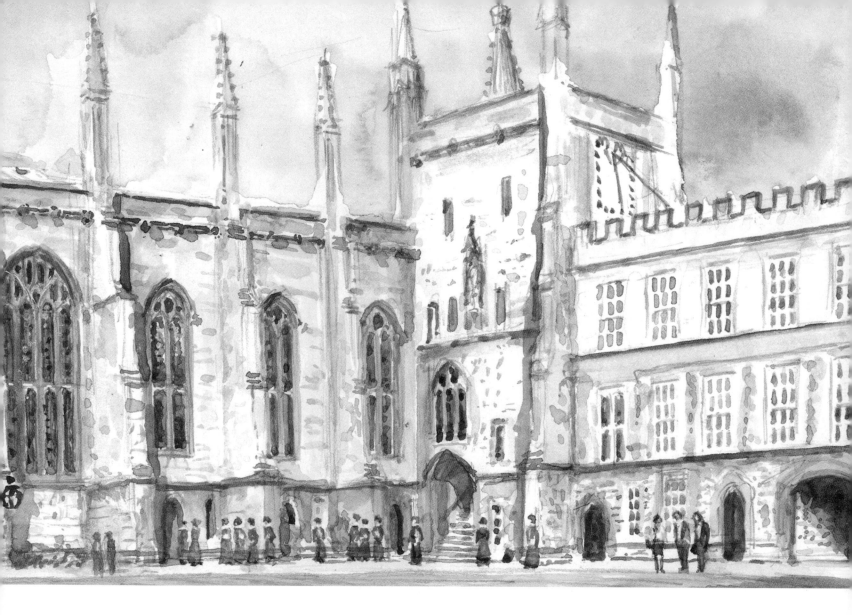

T-shaped like the incomplete chapel at Merton. Even so it is one of the largest in Oxford. On the north side, divided from the chapel by the town wall, is a tall bell-tower.

The chapel is lit by tall Perpendicular windows divided by boldly projecting buttresses. The dining hall of three bays to the east of the chapel is raised over an undercroft and so is entered up a flight of stairs. The interior was virtually completed by 1400 but for linenfold panelling added in the 1530s and a new roof in the 1870s. The first expansion beyond the original buildings was the addition of Garden Quadrangle in 1682. The college really grew in the 19th century, partly due to the abolition of Founder's kin, whereby entry and fellowships were only open to Wykehamists, as well as the renunciation of the privilege of members taking degrees without public examination. In the 1890s the Holywell Quadrangle was built to the north of the City Wall along Holywell Street in collegiate Tudor by architect Basil Champneys. This quadrangle has a special magic in the late afternoon, with the strong shadows advancing over the immaculately kept lawn, and perhaps the sound of the organ, and choristers in the chapel preparing for evensong.

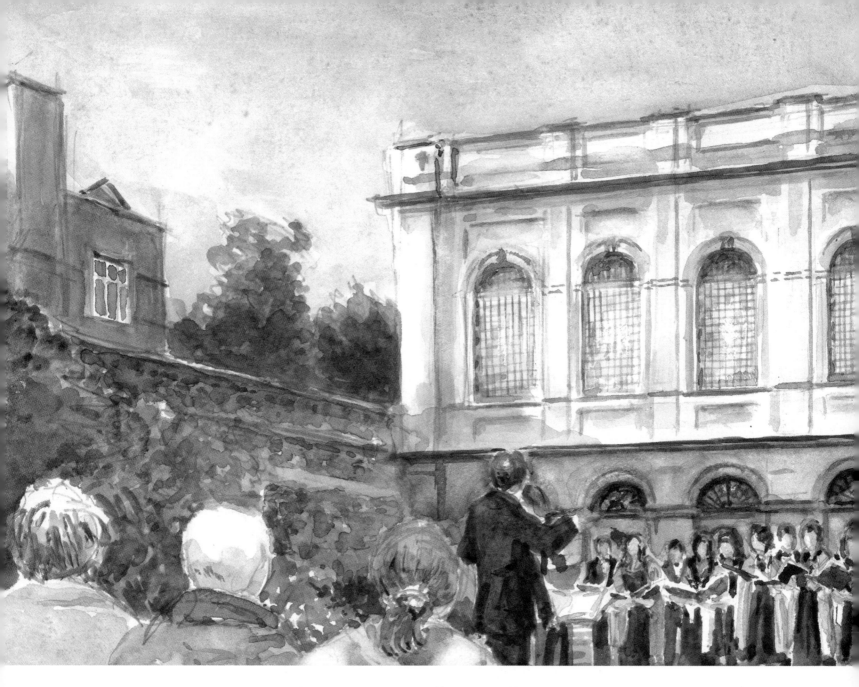

The Queen's College: Fellows' Garden

One of the special delights of Trinity Term at Oxford are the plays and concerts performed in college gardens. Queen's may not have the largest garden but what a backdrop for the second half of the annual summer concert which starts before the interval in the chapel. Here, as the evening sun shines on the golden stone of the library, one can sip wine during the interval. Queen's Library was the first library to be built in the classical style between 1692-95, and replaced a medieval one dating from at least the 1380s. Although at first sight it is reminiscent of Wren's slightly earlier library at Trinity College,

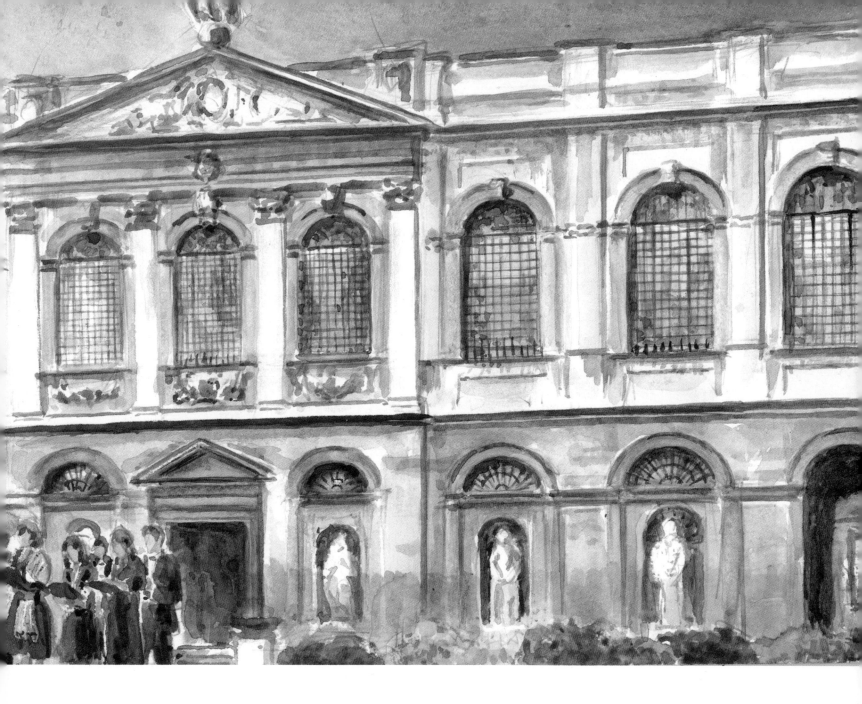

Cambridge, it has been attributed to Dean Aldrich of Christ Church, from whom a design, later refined, survives in the Aldrich collection at Christ Church Library. On both east (quadrangle) and garden fronts the central triple bays are emphasised by a pediment surmounted by an eagle, the emblem of the college founder in 1340-41, Robert Eglesfield, after whom the musical society is named. The library is lit by large windows flooding the interior with light. The lower or ground stage was enclosed in 1843-45 and embellished with niches, and the undercroft behind was converted to form a lower library in the 1930s.

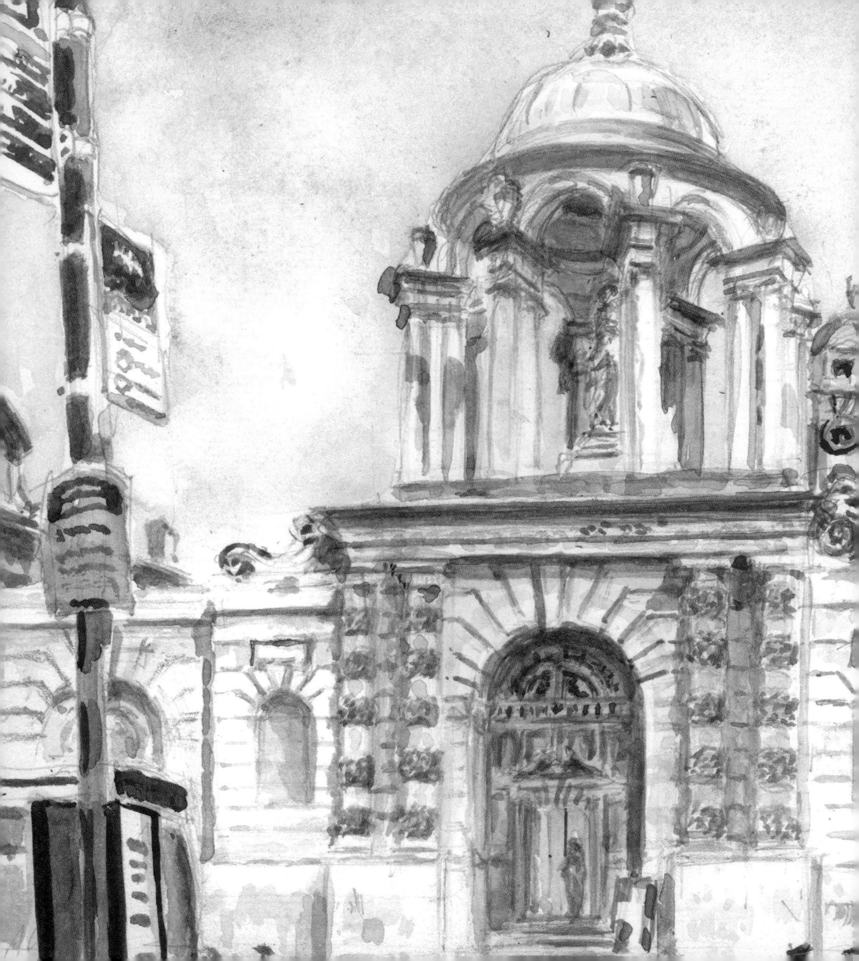

The Queen's College: entrance

The Queen's College, was founded in 1341 by Roger Eglesfield, a native of Cumberland and chaplain to Queen Philippa, wife of Edward III. By the early 18th century the original buildings were in a state of decay and these were demolished leaving the Williamson Building from the 1670s and the magnificent library from the 1690s. The entrance to the college had been in Queen's Lane and in the new building, this was to be a main focus in the design of the High Street frontage. Nicholas Hawksmoor was involved in initial designs. However, these were too grand and were modified by George Clark with William Townsend as resident mason. The idea of a quadrangle enclosed by a walled screen of rusticated courses inset with niches against the street was probably inspired by Salomon de Brosse's Palais de Luxembourg from the 1620s. The provost, William Lancaster, who proposed the rebuilding, had spent some time in Paris. The Palais is entered beneath a domed pavilion and the entrance is topped by a cupola. The Queen's College cupola encloses a statue of Queen Caroline of Ansbach, wife of George II who contributed to the completion of the rebuilding in 1736. Directly opposite the entrance is the north range containing a central passage with the hall on the west and chapel on the east, an idea derived from Wren's Chelsea Hospital where Hawksmoor had worked as assistant surveyor.

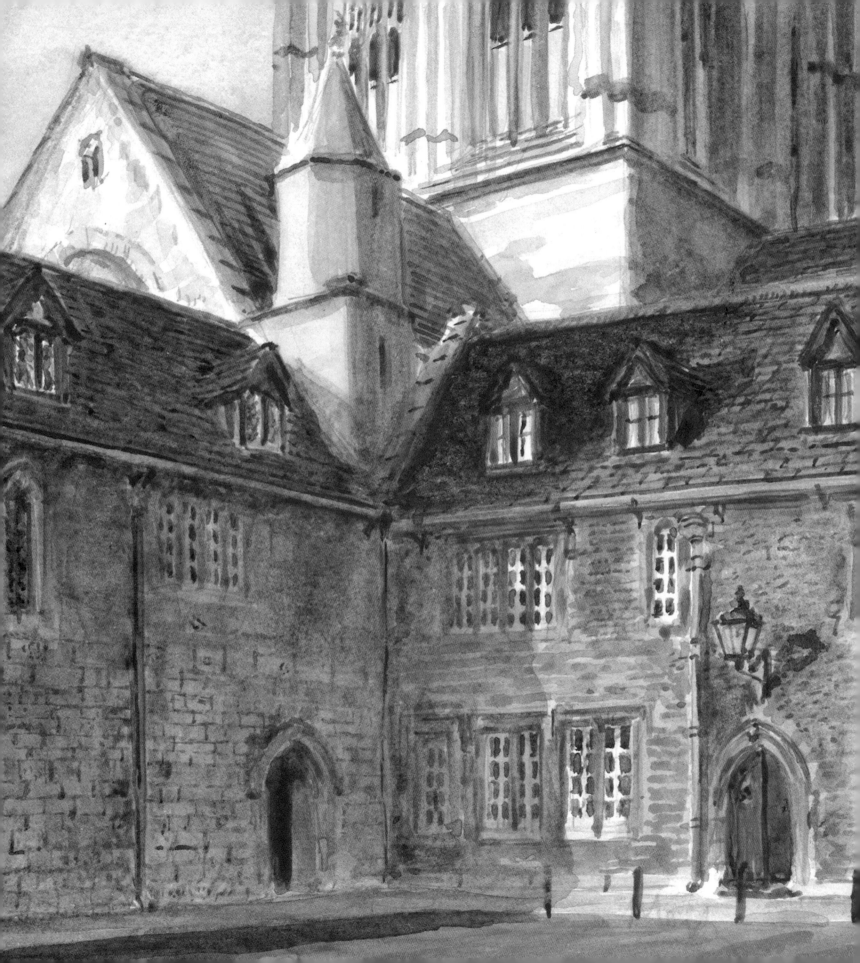

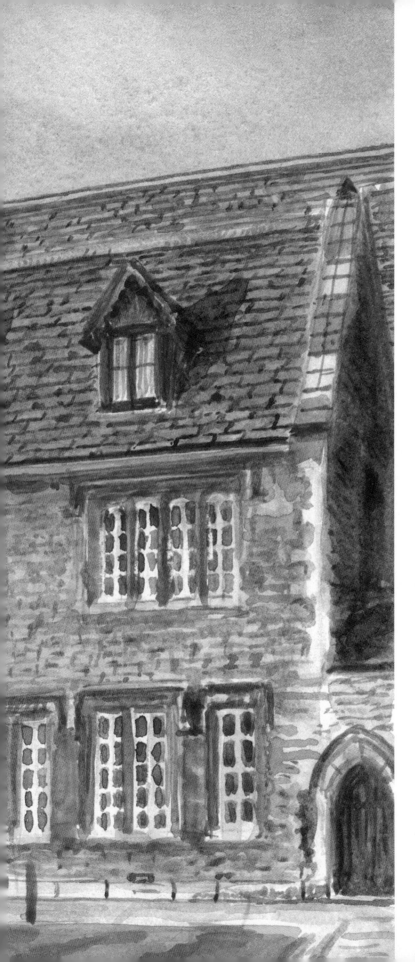

Merton College: Mob Quadrangle

Merton is the oldest college, with its original foundation statute dating from 1264 when Walter de Merton, bishop of Rochester, began buying land in Oxford for a college for 'clerks', that is those studying for priestly orders. This quadrangle is the oldest complete example in Oxford and was built in stages between 1308 and 1378, and from it we get some idea of the original appearance of the medieval student chambers which would have been originally lit with narrow single-light windows. Some of these windows remain in the upper storey of the west and south ranges lighting the library. The other windows are 15th-century or later. Beyond we see the huge chapel with the choir to the right of the tower built between 1290 and 1297. The name 'Mob Quad' is obscure and was not commonly used until the late 18th century: it may have been a humorous reference to the occupants. The lawn is a 20th-century addition.

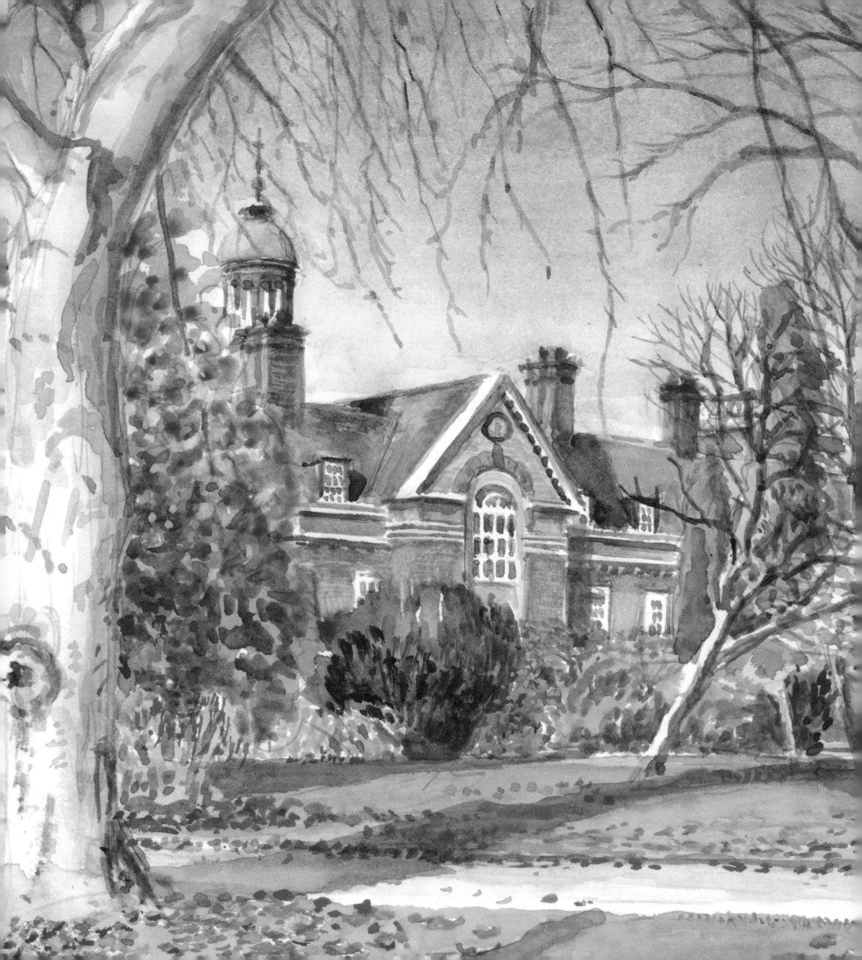

St Hugh's College

It was only in the late 19th century that higher education for women was taken seriously in England, encouraged by the foundation of a number of schools for girls teaching an academic curriculum comparable to the ancient boys' grammar schools. Indeed several, such as Cheltenham Ladies' College and the North London Collegiate School, even introduced science to the curriculum. With these reforms and the education of girls for the professions, there was pressure on universities to admit women. Girton College, Cambridge, was founded in 1873 but women were not admitted to full degrees until 1948. At Oxford the first women's colleges were Lady Margaret Hall and Somerville, both founded in 1879, with full degree status granted in 1920. Women were admitted to full degrees at London from 1878 and Durham in 1896.

St Hugh's was founded in 1886 and first occupied a house in Norham Gardens near Lady Margaret Hall. In 1913 it acquired land between Banbury and Woodstock roads and commissioned H.T. Buckland and W. Hayward to design a block in red-brick neo-Georgian to sit in an extensive garden. This block, dominated in the centre by a steep-pitched gable and belfry, was finished in 1914 and promptly became a hospital for those wounded in the First World War. Since the Second World War the college has doubled in size with some exciting modern buildings along St Margaret's Road, as well as acquiring Victorian houses in Woodstock and Canterbury roads. It has, however, managed to retain so much of the beautiful gardens.

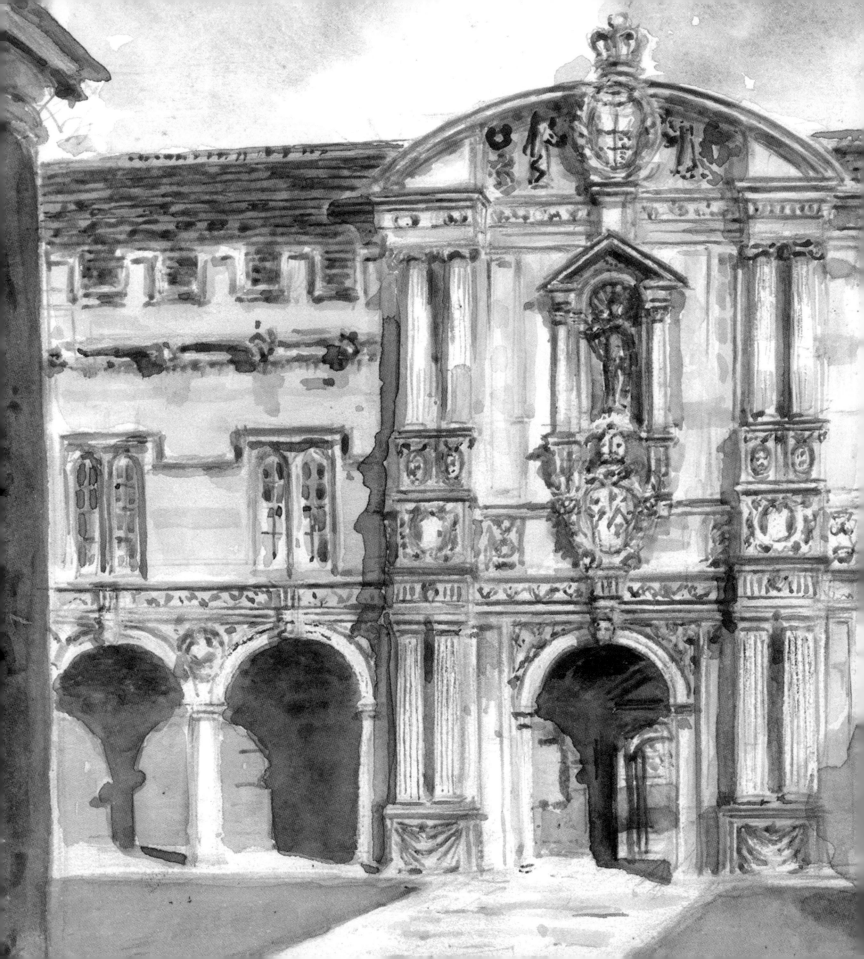

St John's College: Canterbury Quadrangle, east range

Surely one of the most beautiful Oxford colleges it was founded in 1555 by John White, a London merchant, on the site of the former college of the Cistercian order of St Bernard, founded in 1437. The entrance front and quadrangle therefore are mid-15th century; however, the Canterbury Quadrangle was built between 1631-36, perhaps by the king's mason, Nicholas Stone, to commemorate Archbishop Laud's term as president. It is a mixture of traditional crenellated ranges pierced by double-light openings, with those on the east and west sides incorporating a ground arcade of the Tuscan order, reminiscent of a Florentine palace. The Italianate centrepiece incorporates tiers of paired Tuscan and Ionic (upper) pillars. In the tabernacle-niche is a bronze statue of Charles I by Hubert Le Sueur set above a cartouche of the college arms. At the summit is a semicircular pediment incorporating the royal arms and a crown at the apex. Beyond the central arch is one of the largest college gardens in Oxford.

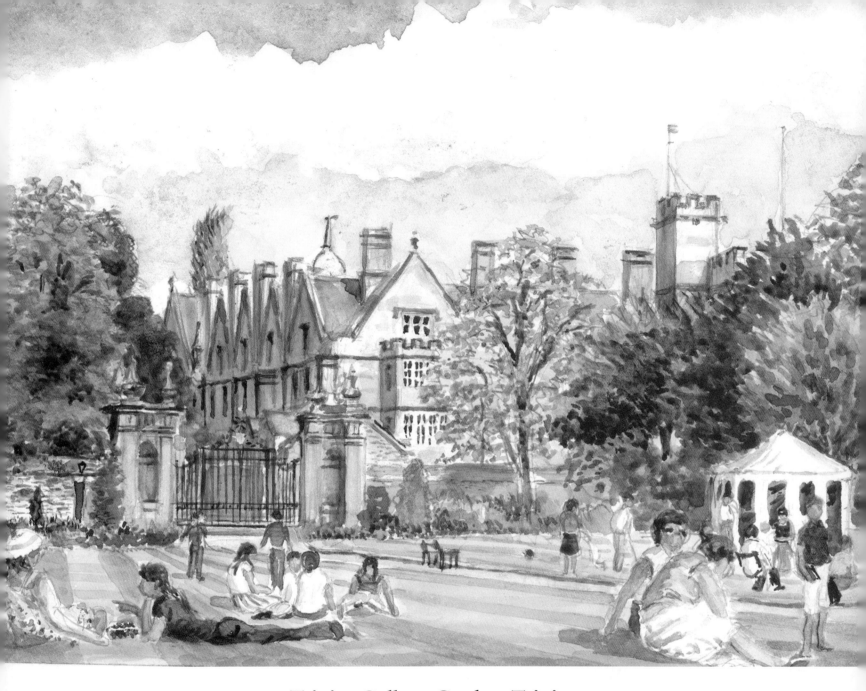

Trinity College Garden: Trinity term

One of the delights of the all-too-short undergraduate Trinity term is the opportunity to spend time in the gardens playing croquet, or just sitting around talking, providing that is, that the pressure of impending exams is not too great. Trinity has one of the finest gardens with extensive lawns extending to the 'closed' gate on to Parks Road. In the background are the early 17th-century buildings of Wadham College.

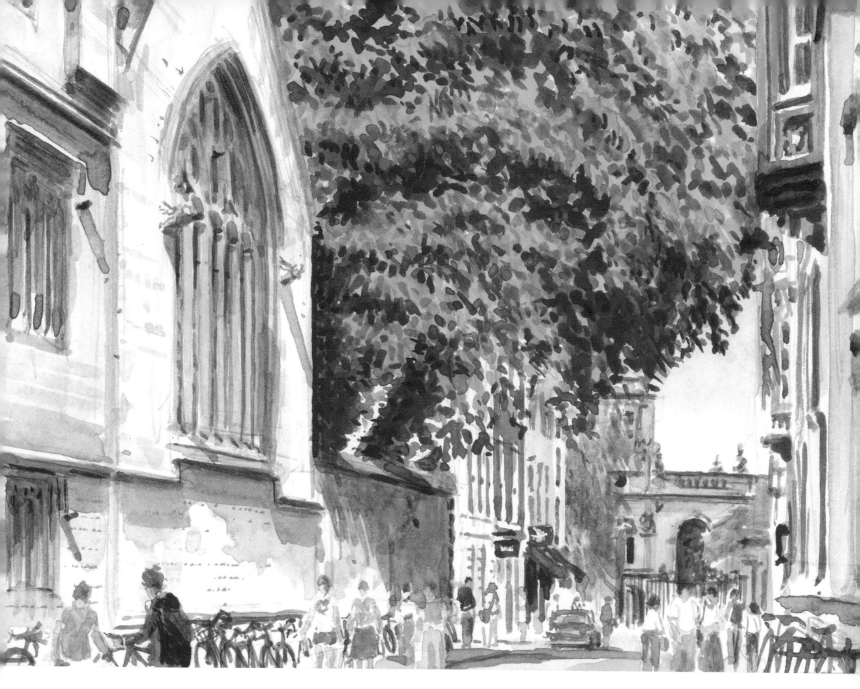

Jesus College and Turl Street looking north

Breaking the view is the lovely tree beside the chapel of Jesus College. This is one of Oxford's smallest and most intimate colleges, founded in 1571 on the site of the medieval White Hall by Dr Hugh Price, who petitioned Queen Elizabeth that she 'would be well pleased to found a college in Oxford on which he might bestow his estate for the maintenance of certain scholars of Wales, to be trained up in good letters'. The east end of the chapel against Turl Street was built in 1636. Opposite is the 19th-century frontage of Exeter College with the chapel of Trinity College beyond.

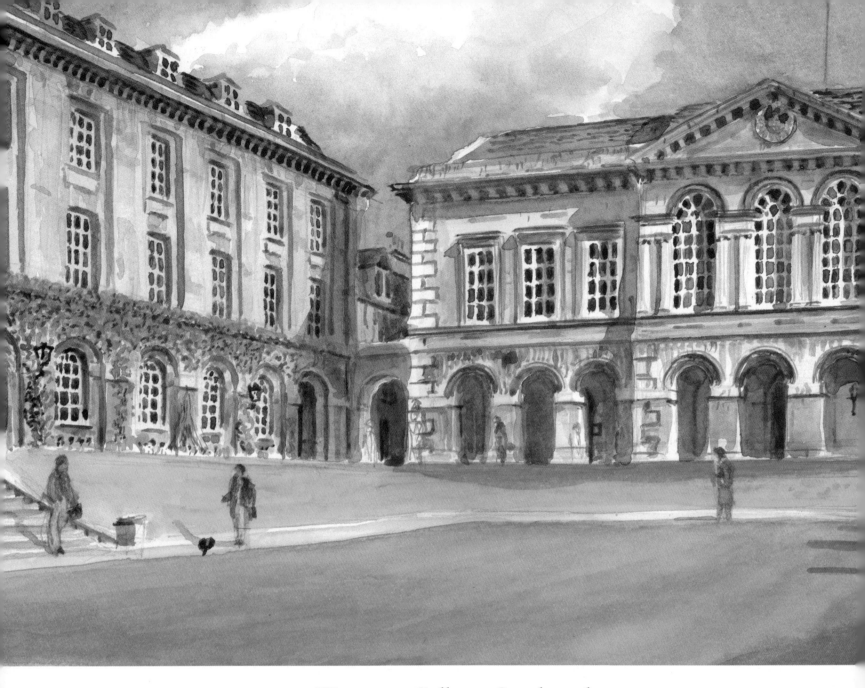

Worcester College: Quadrangle

Worcester seems a little off the beaten track. It was founded in 1714 by Sir Thomas Cooke, having taken over the former buildings of Gloucester College, founded in 1283. Cooke was a Worcestershire landowner who left £10,000 to build 'an ornamental pile' for fellows and scholars in Oxford. This proved not to be enough for the grand buildings intended to occupy the site of the demolished medieval college and progress was slow. The design of the main block, containing the library above an arcade, and with extended wings at both ends containing chapel and hall, was by Dr George

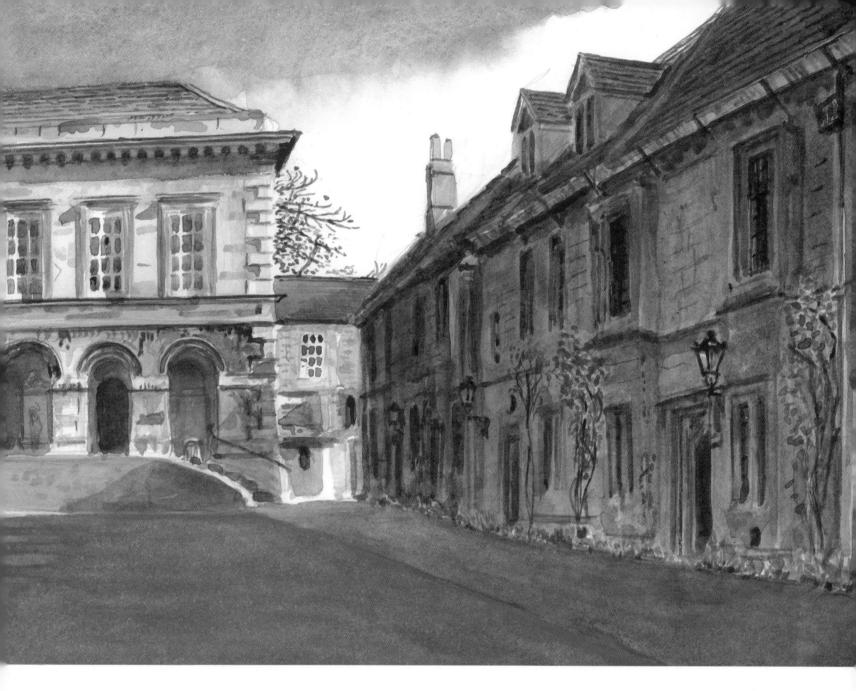

Clarke of All Souls, who consulted Hawksmoor and William Townesend, both of whom had been involved in the classical rebuilding of The Queen's College. Two ranges were intended to flank each other on either side of the quadrangle; only that on the north (left-hand side of picture) to Clarke's design was built in the 1750s with the Provost's Lodging at the west end in the 1770s. Fortunately the south range was not built, so allowing the range of chambers or *camerae* from Gloucester College to remain. Gloucester College had provided accommodation for students from Benedictine houses within the province of Canterbury. The coats of arms of St Augustine's, Canterbury, Pershore, Glastonbury and Malmesbury still remain over the doorways.

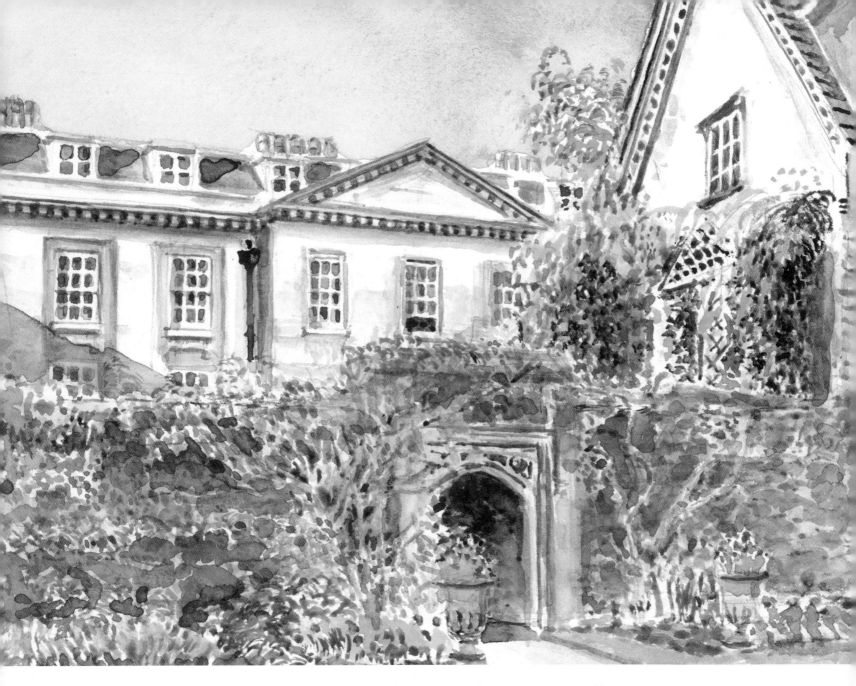

Worcester College: former Gloucester College range

This range dates from the 15th century and looks highly picturesque from the south garden with its array of gables, varied roof pitches and chimneys. The block on the right with the wide chimney-breast is the kitchen of the medieval college. Many medieval college and academic hall buildings would have looked like this although most of the windows are now sash. The range provides a striking contrast to the classical north range beyond the garden arch.

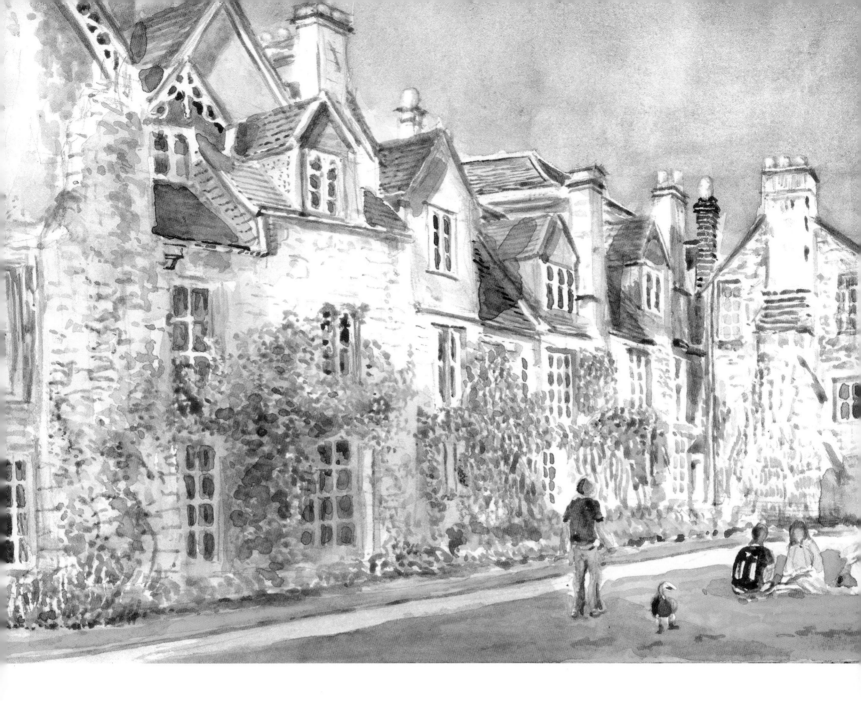

Beyond the Colleges

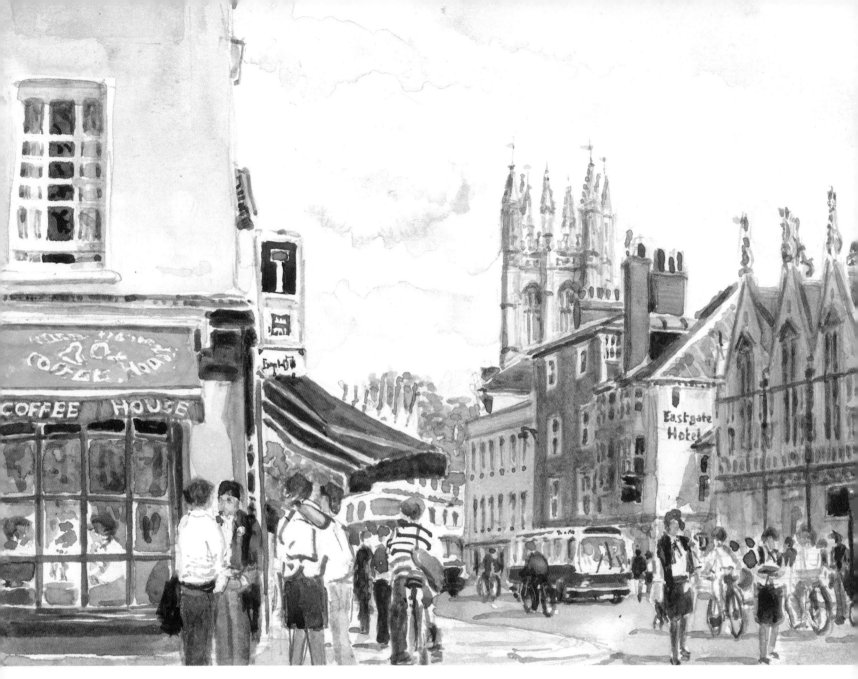

Schools

The culmination of an undergraduate career is at the final examinations known as *schools*, which, for most, take place at Thomas Jackson's purpose-built Examination Schools of 1877-82. This imposing building on the south side of the High Street is in a mixture of Elizabethan and Jacobean styles, sometimes nicknamed 'Anglo-Jackson'. Until the early 19th century examinations were oral and limited to a few subjects and not least classics and theology. In 1800 examination statutes were passed establishing a system of pass and honours degrees obtained by written examinations. As the university expanded so the Schools rooms in the Bodleian quadrangle became too small, and Jackson, a graduate of Wadham, won the

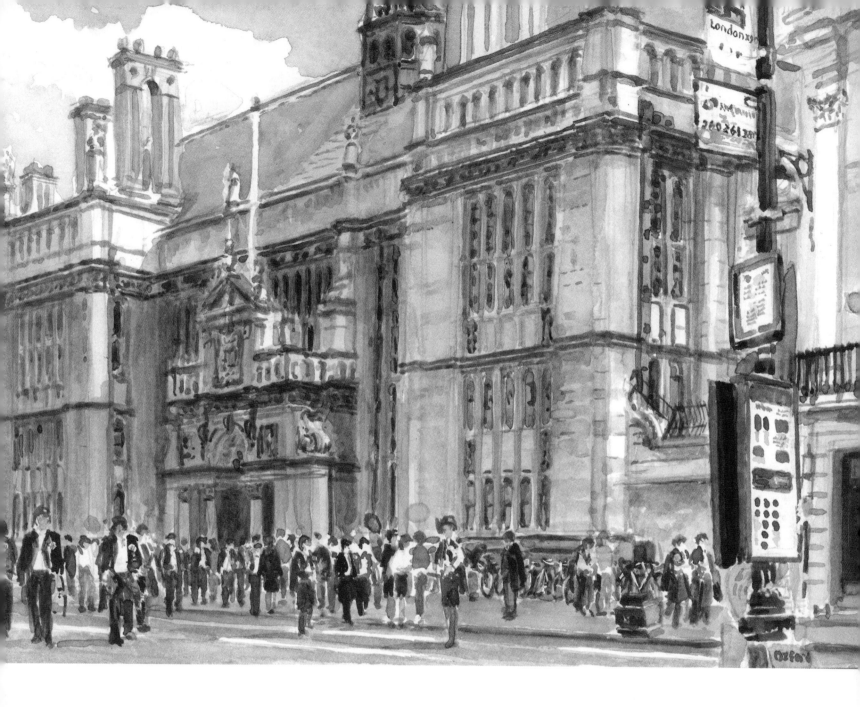

commission for a new building on the site of the Angel Inn. It contains both examination halls and lecture rooms. By the 1990s the numbers of final-year students had grown too large to be accommodated for the 'schools' season in May and June so another large hall in Ewert House, Summertown, has become the alternative, if less celebrated venue. Unique to Oxford is the subject of dressing in *sub-fusc,* black and white, and a carnation, for university examinations. The coffee house at the corner of Queen's Lane has an 18th-century frontage over a much older structure. It claims that coffee was sold here in the late 17th century.

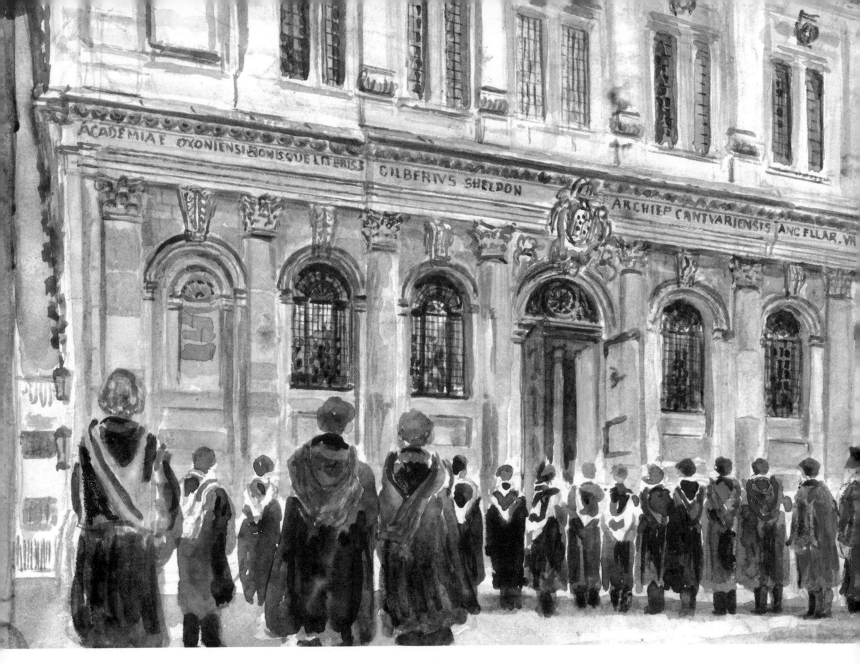

Degree Day: the Sheldonian Theatre

Unlike Cambridge where the degree ceremony takes place at Senate House shortly after results are published, with batches of colleges being granted a specific graduation day, at Oxford it is up to the student to apply for a date in the degree day cycle of the following academic year. The Sheldonian, built for university ceremonies as a result of a gift of £12,000 from Gilbert Sheldon, archbishop of Canterbury, provides a memorable setting. It was designed by Christopher Wren, then Savilian professor of astronomy. It was his second design, after Pembroke College chapel, Cambridge, and opened in 1669. The plan is

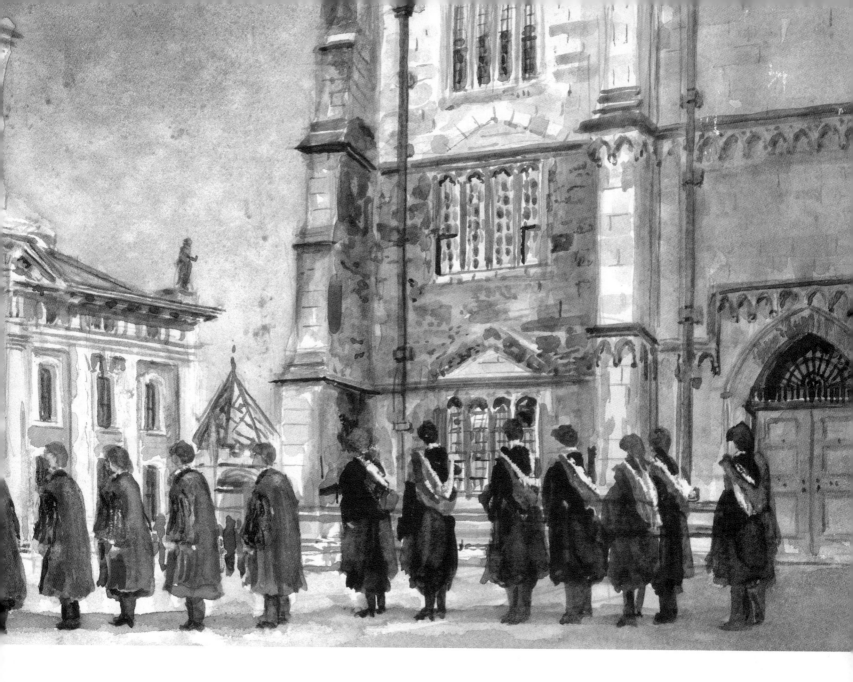

based on the antique U-shaped Theatre of Marcellus in Rome from Sebastiano Serlio's reconstruction, and the elevation from Palladio's reconstruction of the theatre. The façade towards the Divinity School shows Wren's attempt to present a screen to the interior. It is of two stages, seven bays wide and divided by an entablature and cornice marking the level of the gallery within. The interior is remarkable for Wren's creation of a structure of beams to support the roof panels wholly from above. The surrounding galleries are supported on wooden columns painted to resemble marble.

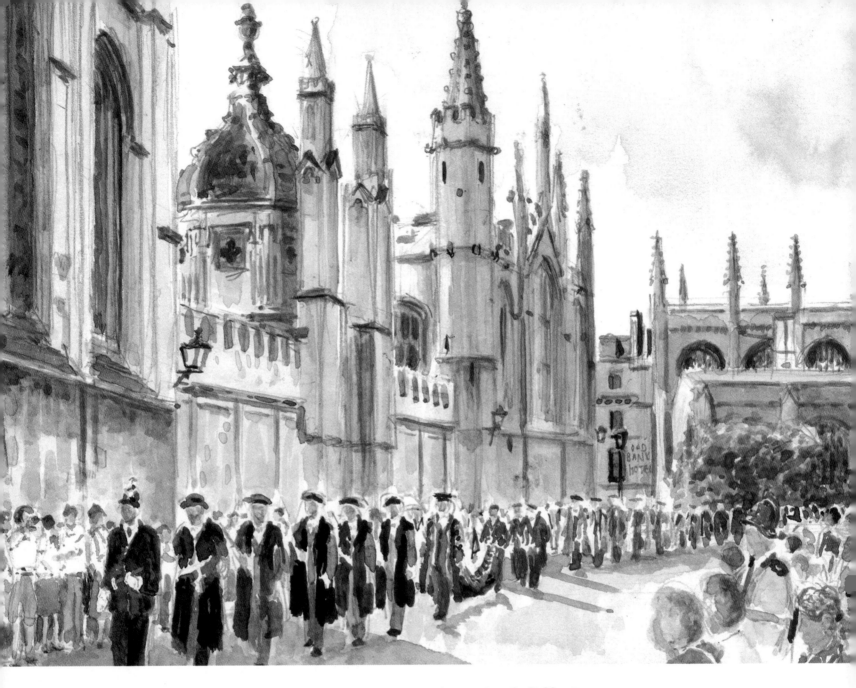

Encaenia Procession, Radcliffe Square

Trinity Term ends in celebrations as it is also the end of the academic year. Encaenia (from the Greek: a festival of dedication or renewal) takes place on the Wednesday of ninth or Commemoration week and lasts all day. Originally the ceremony took place in the university church but its secular nature was one of the reasons for the building of the Sheldonian Theatre. A bequest for the ceremony was left in the will of Nathaniel Crewe, sometime rector of Lincoln College. This is commemorated by a reception of peaches, strawberries and champagne before the chancellor, university officers and heads of houses process to the Sheldonian Theatre where honorary degrees are granted (in Latin) to distinguished world figures. This

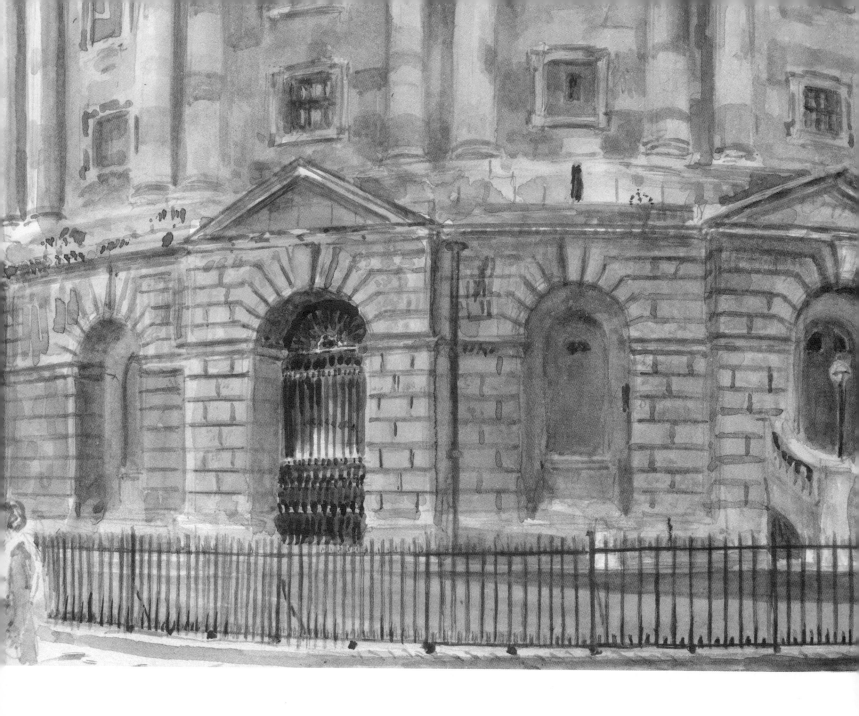

is followed by the Creweian oration, a review of the year, read either by the public orator, or professor of Poetry. After lunch at All Souls, a garden party takes place there, or in one of the nearby colleges.

It is perhaps appropriate that the procession has just passed the Old Convocation House (behind the tree) attached to St Mary's church and which dates from the 1320s. Here was the heart of the medieval university where Congregation, the resident council of Masters of Arts originally met. It also housed the treasury or University Chest and store for muniments. On the upper floor was the university library, the forerunner of the Bodleian.

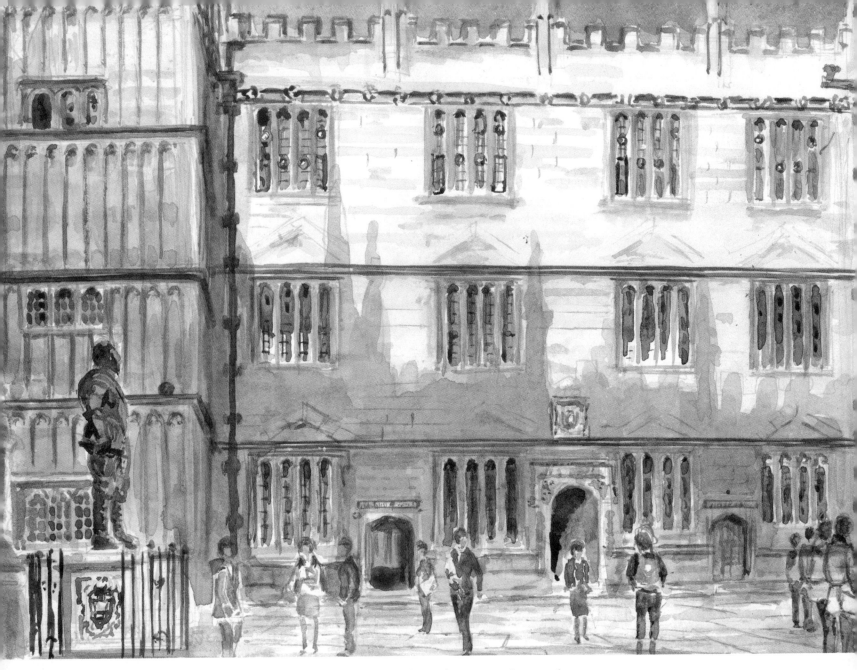

The Schools Quadrangle

There is perhaps nowhere else at Oxford that conveys the atmosphere of learning and scholarship than this quadrangle which was at the heart of the medieval university. What we see today, however, is early 17th century and brought the schools or subject teaching chambers into a single quadrangle adjacent to the Bodleian Library, which was established in 1602. The concept was probably Sir Thomas Bodley's, but the master masons were John Akroyd, John Bentley and Thomas Holt of Halifax, who built the Fellows' Quad at Merton. Originally intended to be of two floors for the schools, a third was added to serve as a book store. In fact it became a gallery for the display of the university's collection of paintings, which were only finally removed to the Ashmolean in 1902. The floors are divided by thin string courses and the walls

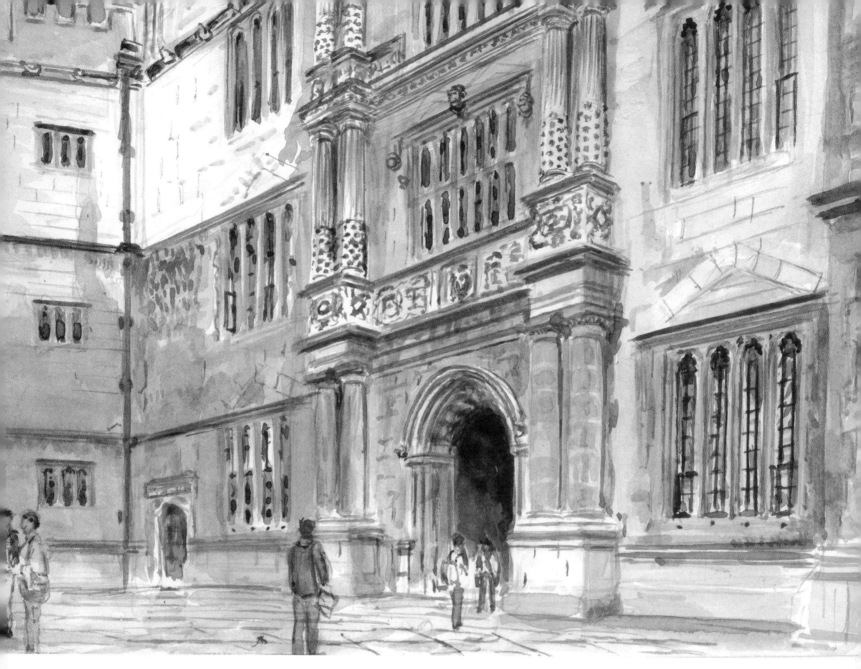

pierced by tall four-light windows. The parapet is crenellated and broken at intervals by pinnacles. Whilst the west side is covered by a screen of blind arcading serving as the Proscholium or entry hall to the library, and as a mask to the Divinity School, our attention is drawn to the five-storey tower which is a mixture of Gothic with an overlay of a Jacobean interpretation of the classical orders. It starts with coupled Tuscan columns, with Roman Doric on the next storey on elaborately decorated bases. The next, in line with the upper floor is Ionic again on decorated bases. Next (above the limit of the picture) comes Corinthian and Composite. The Corinthian stage incorporates a statue of James I presenting a copy of his writings to a kneeling figure representing the university. The statue on the left is of the earl of Pembroke, chancellor of the university, 1617–30. The doorways around the quadrangle retain the carved names of the schools in Latin which represent the Seven Liberal Arts of the ancient university curriculum.

85

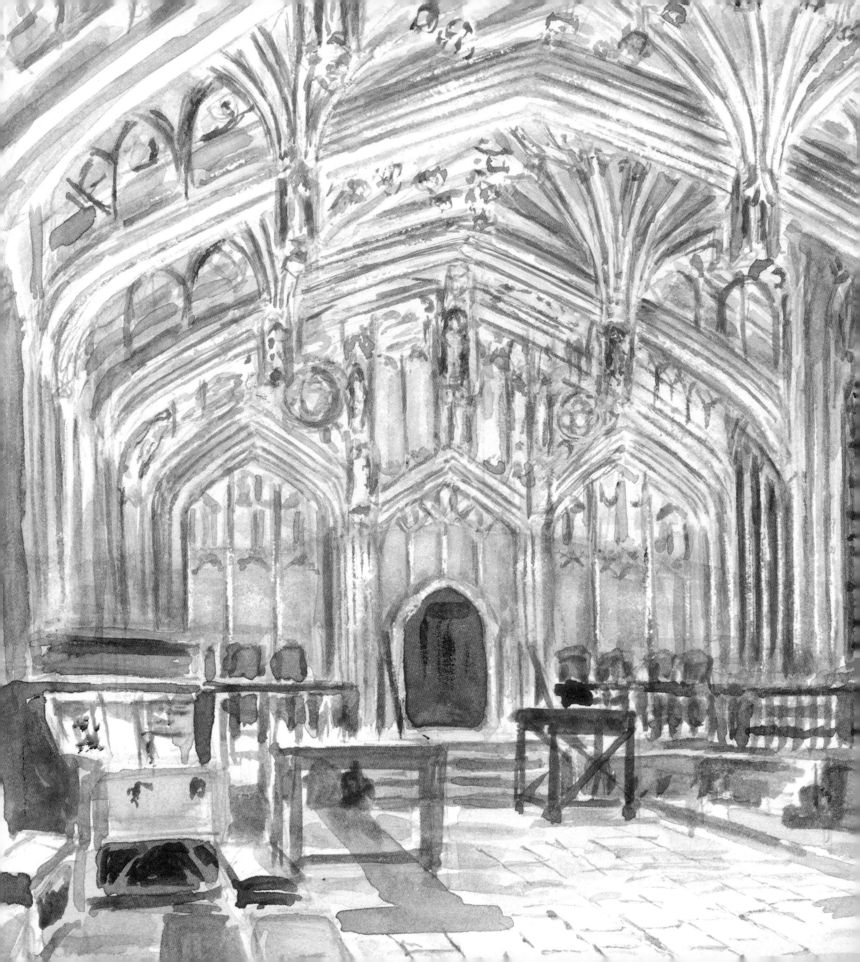

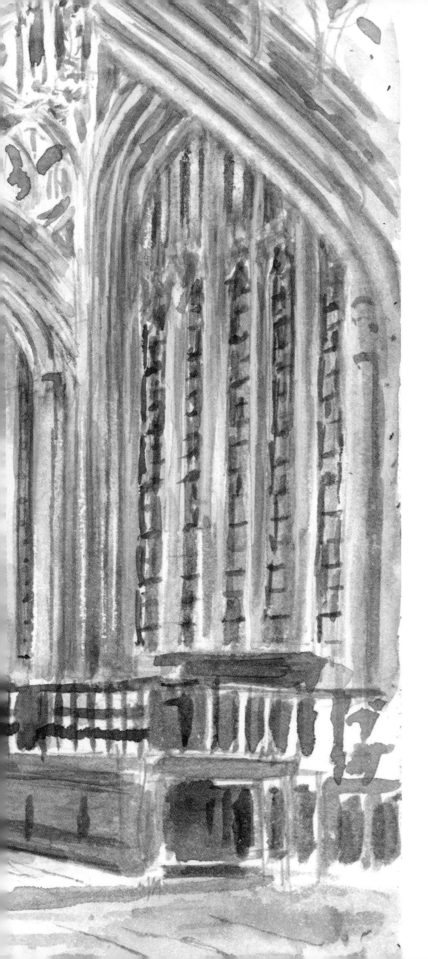

The Divinity School

Perhaps this is one of the least known architectural gems of Oxford, yet in delicacy of ornament it bears comparison with King's College chapel in Cambridge. It is the only surviving medieval lecture room and was built for the teaching of theology. It was originally intended to be a single-storey building, with large windows occupying most of two of the walls while the east and west walls were to be lavishly decorated. The mason appointed was Robert of Winchcombe, and work began in 1430, but came to a halt by 1440 through lack of funds. When it restarted, the new mason, Thomas Elkin, was told to simplify the decoration. In 1444 Humphrey, duke of Gloucester, gave a valuable collection of manuscripts to the university, and for this it was decided to build an upper storey above the Divinity School. Thomas Kemp, archbishop of Canterbury donated 1,000 marks (£666) for the building of the library and this ensured the retention of his memory in coats of arms on vault bosses of the school. The vault was designed by William Orchard and may be described as a lierne vault with transverse arches, carrying hanging pendants which sprout a fan-like cluster of ribs rising to a low-pitch ceiling. The pendants have miniature niches containing figures of saints. Over the centuries the weight of the book stacks above bore down on the stone vault which had to be re-inforced with steel rods during restoration in the 1990s.

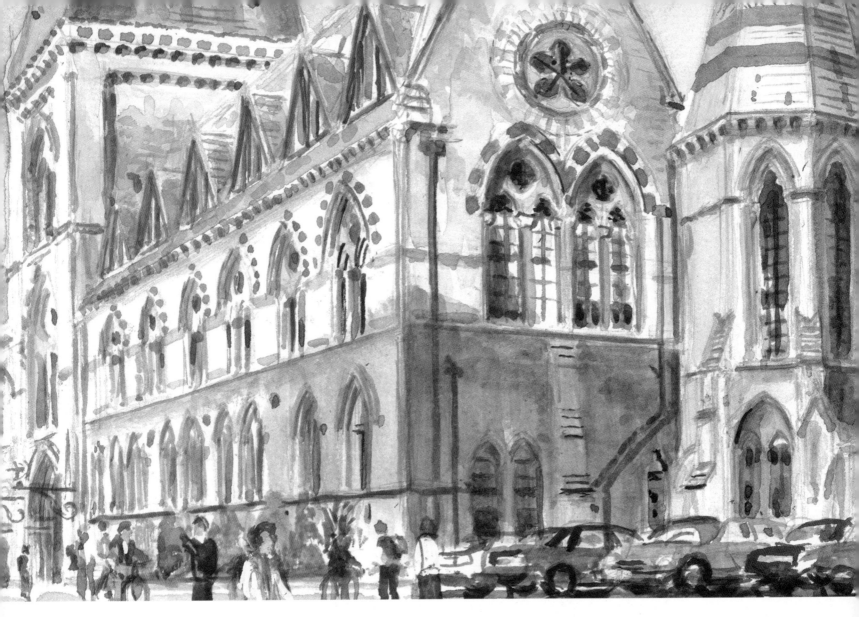

Oxford Museum and Chemistry Laboratory

Until tourist buses started to take in Parks Road, these magnificent 19th-century buildings were missed by many visitors. Now the museum is one of the most popular attractions. When built after a competition in 1854, it was close to open country, and a safe place for a practical chemistry laboratory. The museum was championed by Henry Acland, reader in anatomy and subsequently professor of medicine, who wanted a building for the assembly of 'all the materials explanatory of the organic beings placed upon the globe'. He also wanted the teaching of science put on to the same footing as the established academic schools of the university; an honours degree in natural science had been introduced in 1850. The land was bought from Merton College for £30,000, which came from profits from the University Press. From the thirty-two designs submitted, the short-list consisted of two, a classical design by Charles Barry, and a Gothic one by Irishman, Benjamin Woodward. Acland who was a friend of John Ruskin and

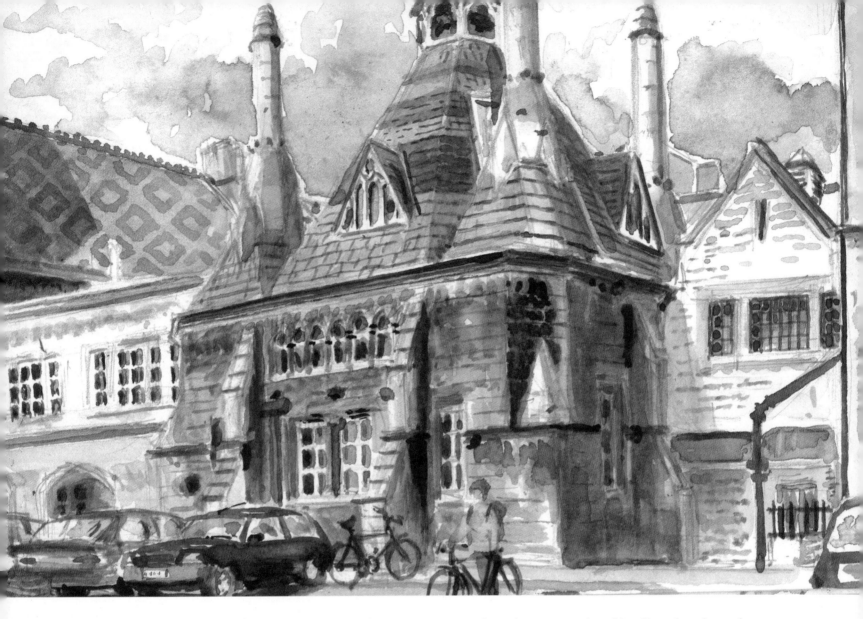

influenced by his *The Stones of Venice*, preferred the Venetian Gothic design. Built of buff and red sandstone, its roof has patterns of grey and mauve slates. The symmetrical front has a tower crowned by a hipped roof, unlike anything else in Oxford, and owing more to north German civic buildings. Some of the upper windows of the front have richly carved details with a mixture of foliage and animals, including cats, dogs, rabbits and hares, by the O' Shea brothers who had worked under Woodward at Trinity College, Dublin. The windows on the ground floor are simpler lancets and, like those above, the intended decoration was never completed. The O'Sheas were supposedly dismissed for having carved caricatures of dons between carvings of parrots and owls although in reality the money had run out by the time the building opened in 1859. The Chemistry Laboratory, built in 1860, was a clever compromise at a time when it was feared that the teaching of science might undermine Christian belief in God and Creation. In order to conquer the prejudice of those who saw scientific progress as a threat, Woodward's design was based on the surviving Abbot's Kitchen at Glastonbury. So science was clothed in a building reminiscent of our medieval Christian

The Botanic Garden

Opposite Magdalen College and beside the Cherwell is one of Oxford's most beautiful attractions. One of the oldest botanical gardens in Europe, it was founded on land leased from Magdalen. Its purpose was to teach medical students about the properties of plants as did the gardens in Florence, Padua and Rome. It was founded in 1621 by Henry Danvers, earl of Danby, for 'the glorification of God and for the furtherance of learning'. He gave £5,000, for 4,000 loads of 'mucke and dunge' to raise the land above the Cherwell flood plain, and the construction of walls and three gates. It was called the Physic Garden until it was renamed in 1840. The first keeper was John Tradescant.

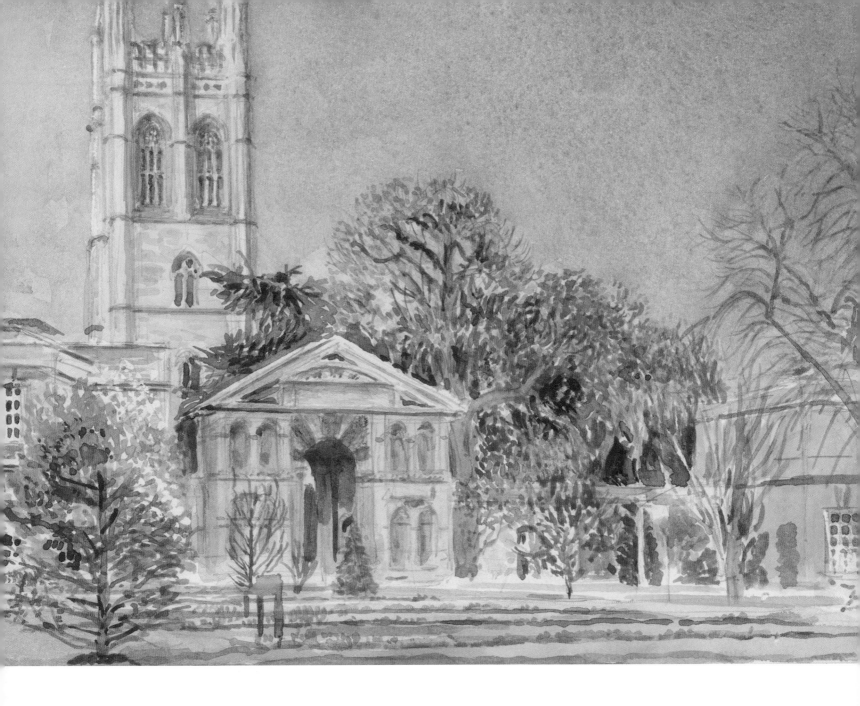

The highly ornate gate in the picture was designed by Nicholas Stone, the king's master mason under Inigo Jones, as a variation on a Roman triumphal arch, with mannerist features including the triangular pediment incorporating a semicircular one, projecting alternating vermiculated courses round the arch, and pairs of blank niches, all features derived from Sebastiano Serlio's *Extraordinary Book of Archways*. The gate is flanked by honey-coloured stone buildings; to the left of the tower is the West Plant House by William Townsend, 1733-35.

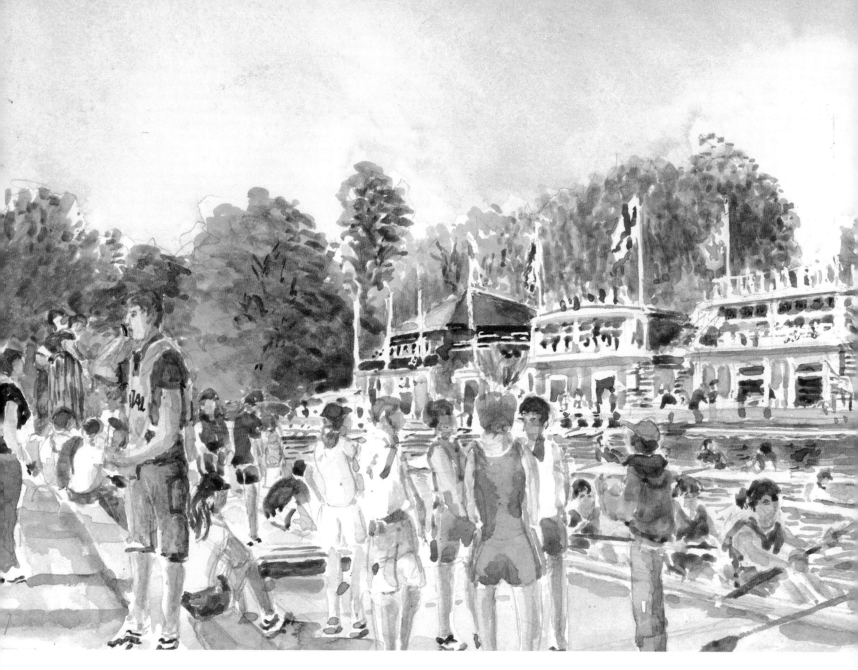

Eights Week

Whilst Eights Week is not the occasion it was when Max Beerbohm wrote *Zuleika Dobson* and spectators were dressed in white and sporting college ties and boaters, it is still a magnificent spectacle of college rowing. It is a series of bumping races which take place over four days from Wednesday to Saturday of the fifth week in Trinity Term. The course is between Iffley Lock and Folly Bridge. Crews start in divisions in the order they finished in the previous year and the aim is to bump the boat in front. It is therefore possible to go up four places if you score a bump each day. The crew which is top of the first division on the final day becomes 'Head of the River' and celebrates with a Bumps Supper. There

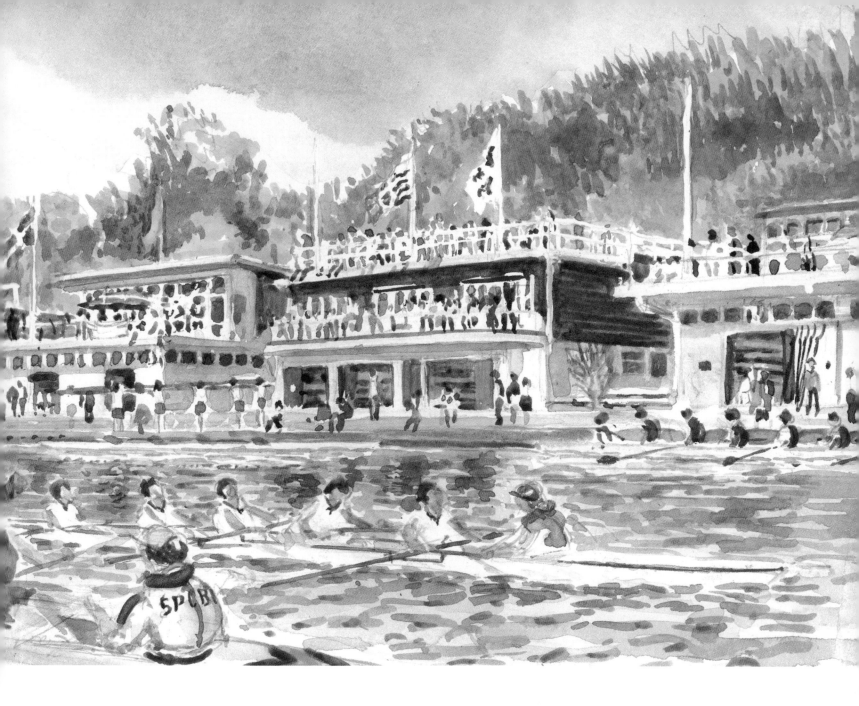

are records of inter-collegiate racing from at least 1825, and the first race against Cambridge took place at Henley in 1829.

Until the late1930s ornate Victorian college barge-houses lined the river bank of Christ Church Meadow. However, they have all been replaced by brick and concrete boat-houses, some less attractive than others. All have balconies from which parents, friends and old members can watch the races in between innumerable glasses of Pimm's.

The last race is usually followed by a Salter's steamer making its way from Abingdon to Folly Bridge; then the day on the river is truly over.

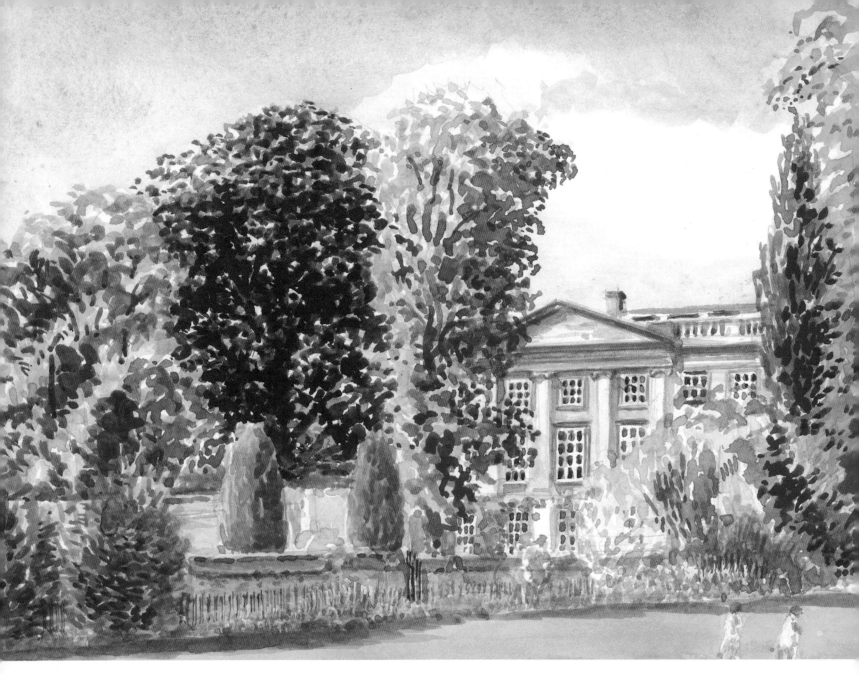

Summer's afternoon, Merton Field

There can be few more beautiful settings for a game of cricket or other summer sport than this field on the north side of Broad Walk which crosses Christ Church Meadow. Here generations of choristers from Christ Church Choir School have relaxed between rehearsals in the cathedral and academic work in their premises in Brewer Street. On the left is the classical garden front of the Fellows' Building of Corpus Christi, built in 1706-12, and attributed to Henry Aldrich, dean of Christ Church. To the right we have Grove Building by William Butterfield, 1860-63, part of Merton College with the majestic tower of 1448-51 to the chapel rising beyond. It must have been the inspiration for the upper stage of Magdalen College bell-tower in 1492.